A Passion for Japan

A COLORING EXPLORATION

ILLUSTRATIONS BY SARA MUZIO

Sara Muzio

Sara Muzio has over ten years of experience working in graphic design and illustration.
In 2002, after earning a degree in Medical Illustration, she began working for small graphic design studios
and in 2004 she became the scientific illustrator for Lumen Edizioni, where she completed a postgraduate course
on publishing and advertising graphics. From 2005 to 2011, she worked as a freelance graphic designer for private
clients as well as public entities and publishing houses. From 2011 to 2013, she was the graphic and packaging
designer for Sambonet Paderno Industrie S.p.A. She currently works as an illustrator and freelance graphic
designer. In the past years, she has realized several books for White Star Publishers.

WHITE STAR PUBLISHERS

WS White Star Publishers® is a registered trademark
property of White Star s.r.l.

© 2019 White Star s.r.l.
Piazzale Luigi Cadorna, 6
20123 Milan, Italy
www.whitestar.it

Translation: Richard Pierce

ISBN: 978-88-544-1625-3
3 4 5 6 25 24 23 22 21

Printed in Italy

A Passion for Japan

A COLORING EXPLORATION

WHITE STAR PUBLISHERS

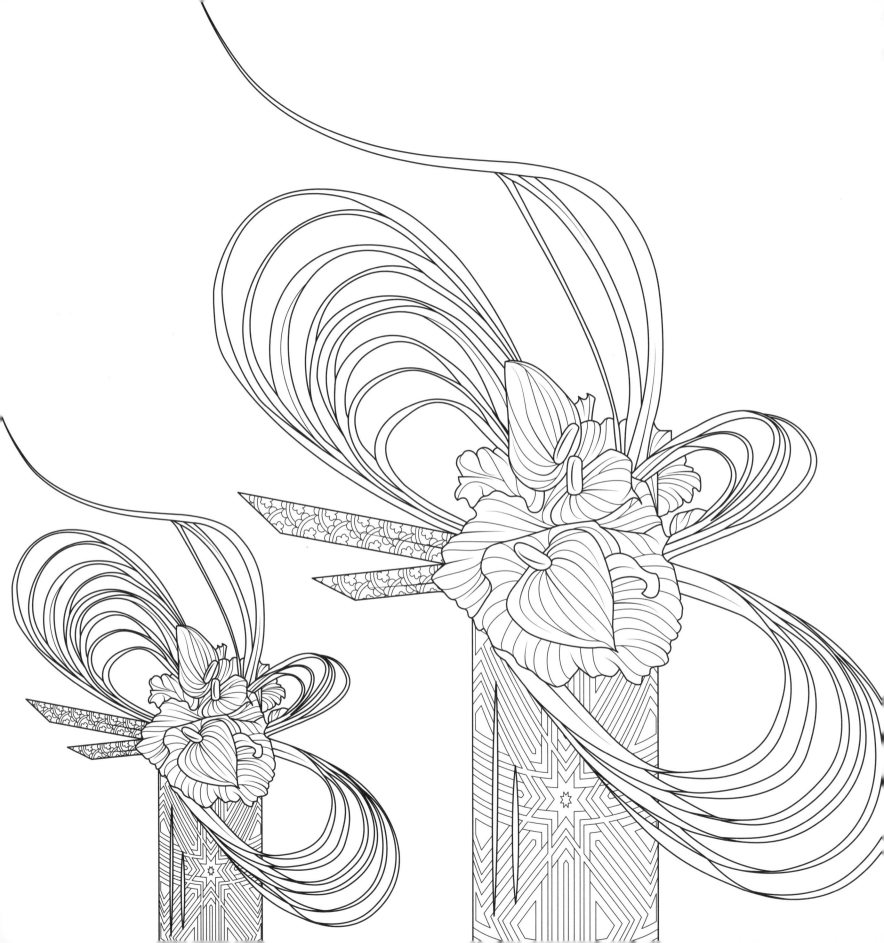

Introduction

There is an expression: *iroiro*, or "a variety of colors," that the Japanese use to express how reality is made up of many different nuances—an infinite supply of colors that constitute the energy and richness of our vibrant world. Is there one color that can epitomize Japan? We're tempted to say pale pink (imagine a cherry tree in bloom), or the brilliant green color found in many marvelous Japanese gardens, or the bright red of a *torii* tower, or even the solid white painted on the faces of geishas and Kabuki actors. But as is the case with many other countries, there is no truly dominant color that can represent the whole of Japan. The country is best represented by the effects of many different hues and shades working together. The plates in this coloring book, which are based on many classic cultural elements found in the "Land of the Rising Sun," include landscapes, celebrities, architecture, animals, and clothes. Let your imagination run wild as you color in paper lanterns, origami cranes, Zen gardens, or the branches of bonsai trees. Whether you're working with pencils, markers, or crayons, you'll find plenty of satisfying scenes here to help you clear your mind and sharpen your creative skills. And along the way you'll receive a fascinating introduction to traditional Japanese culture. So, get your pencils ready and . . . *iroiro*!

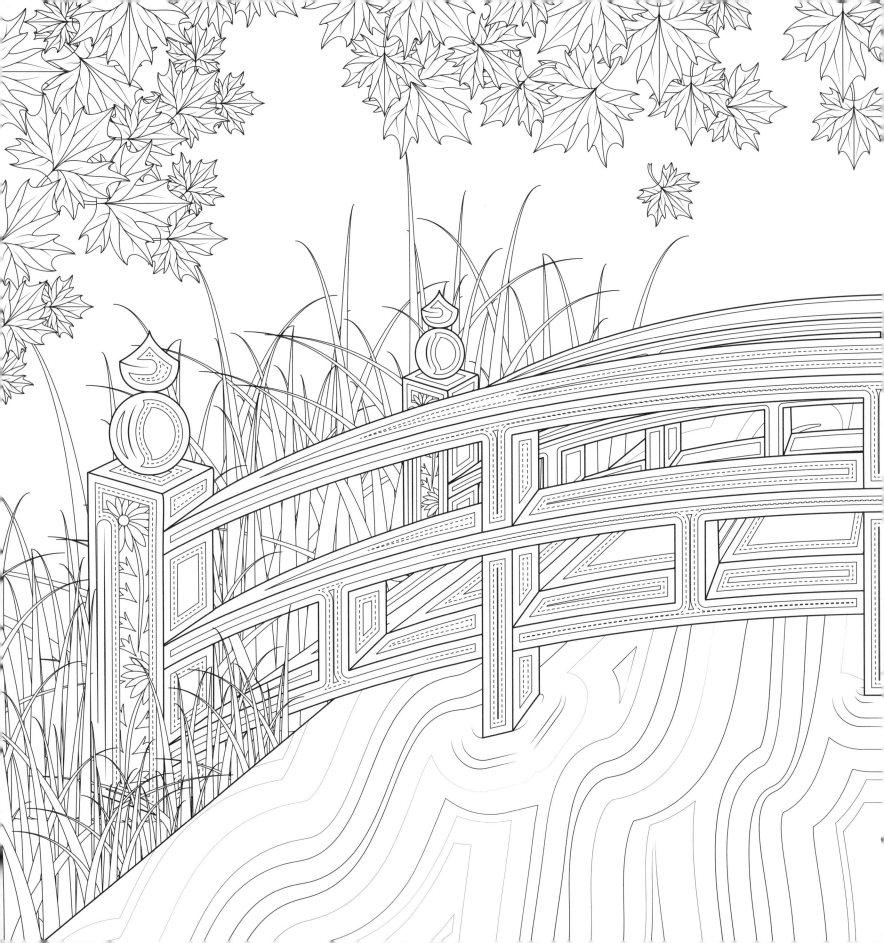

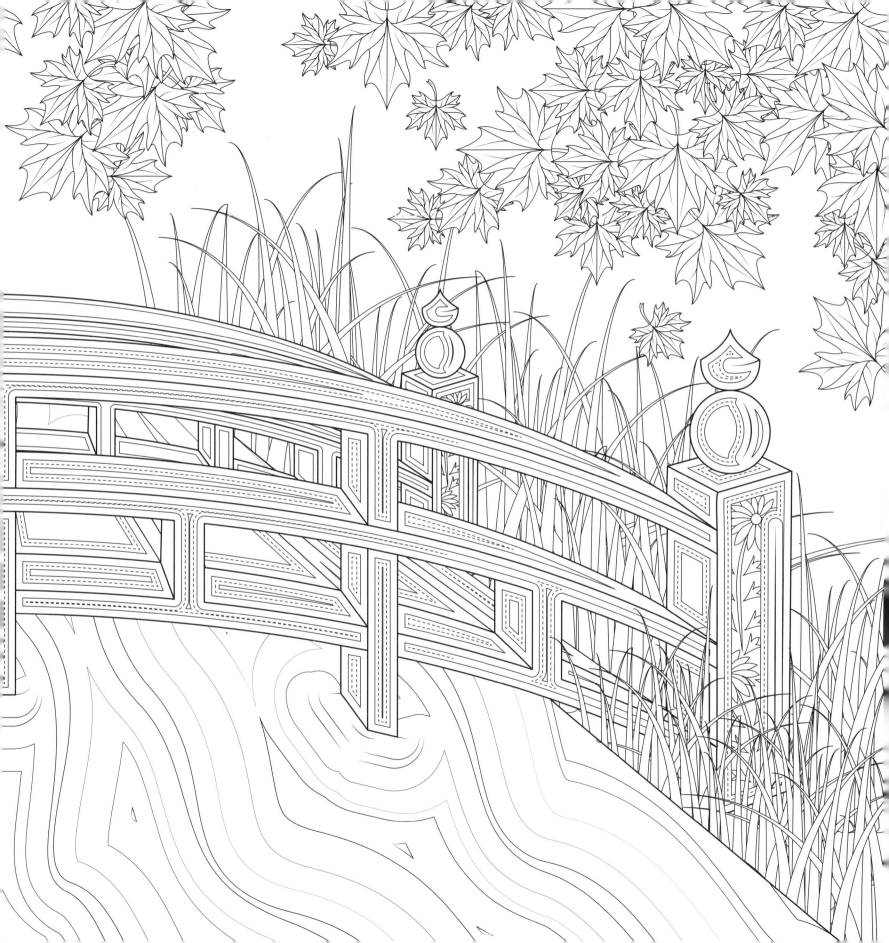

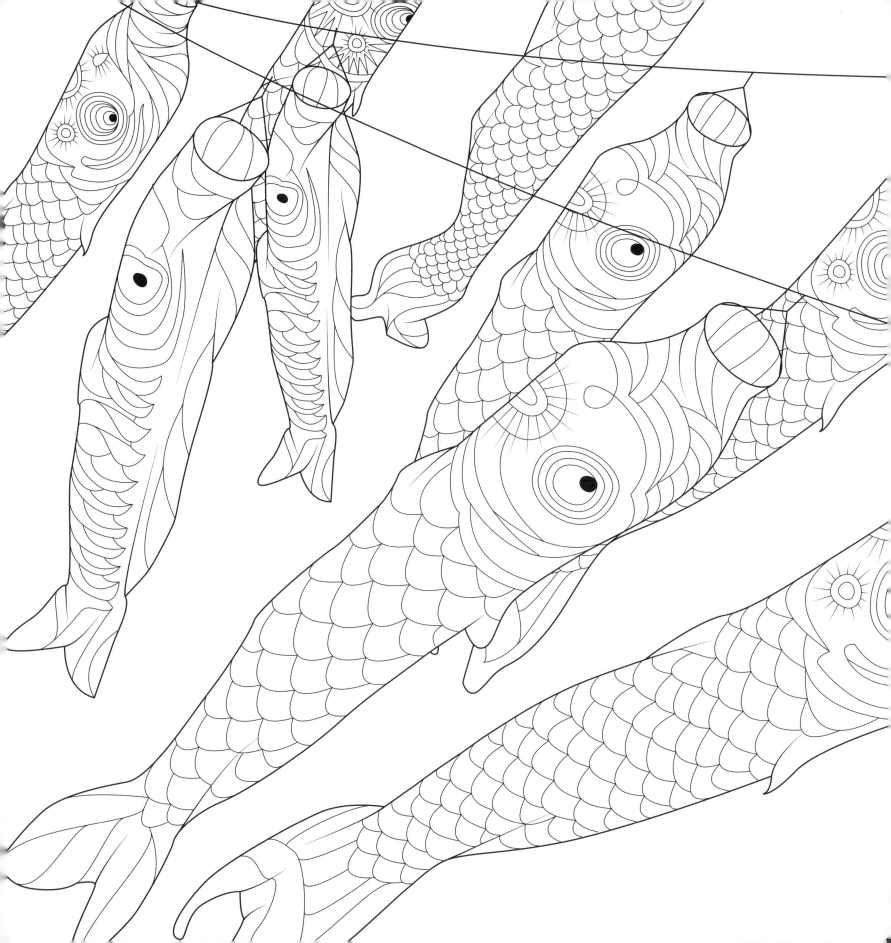

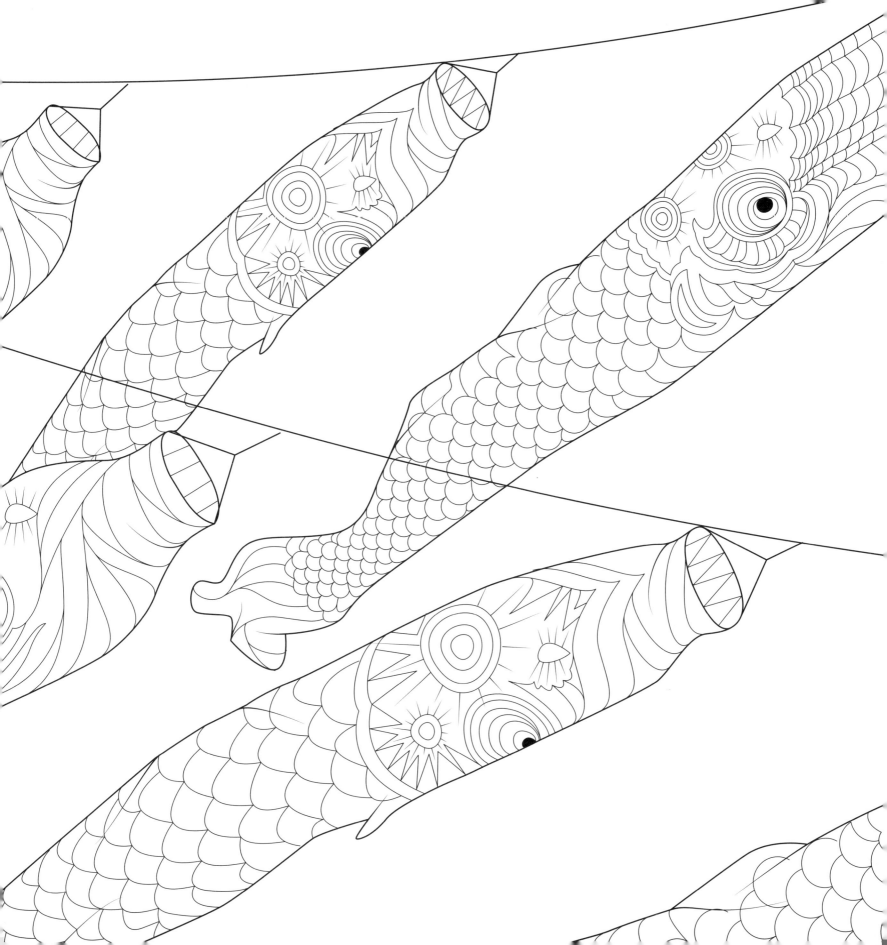

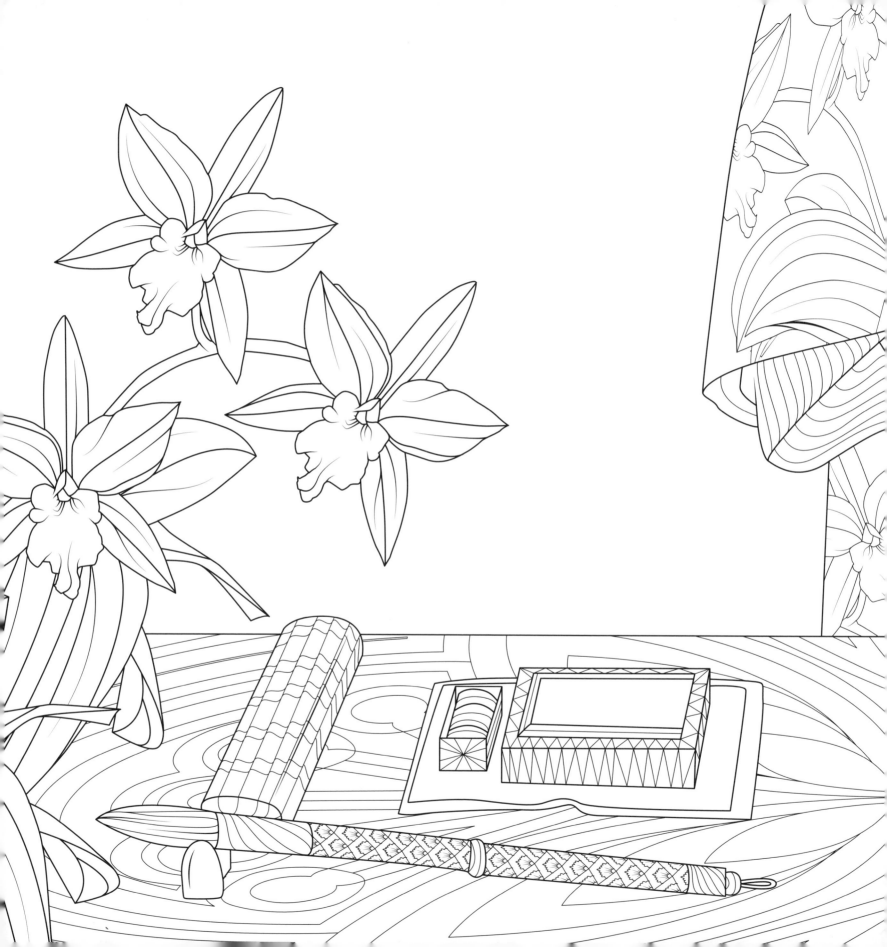

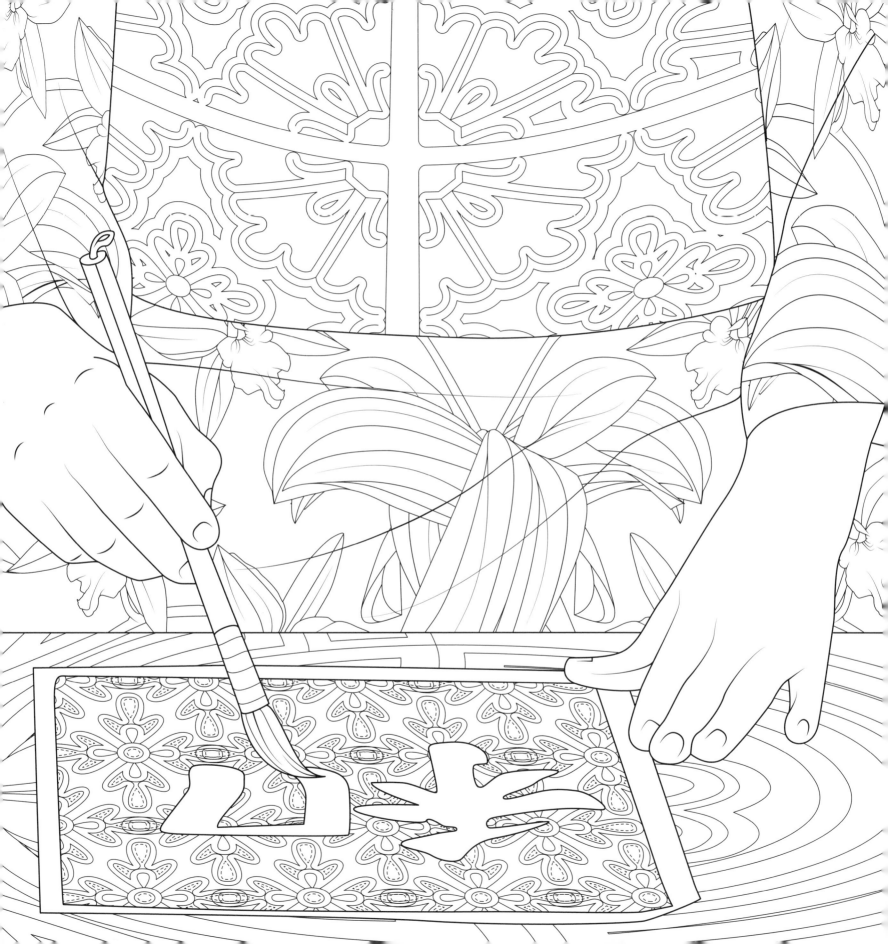

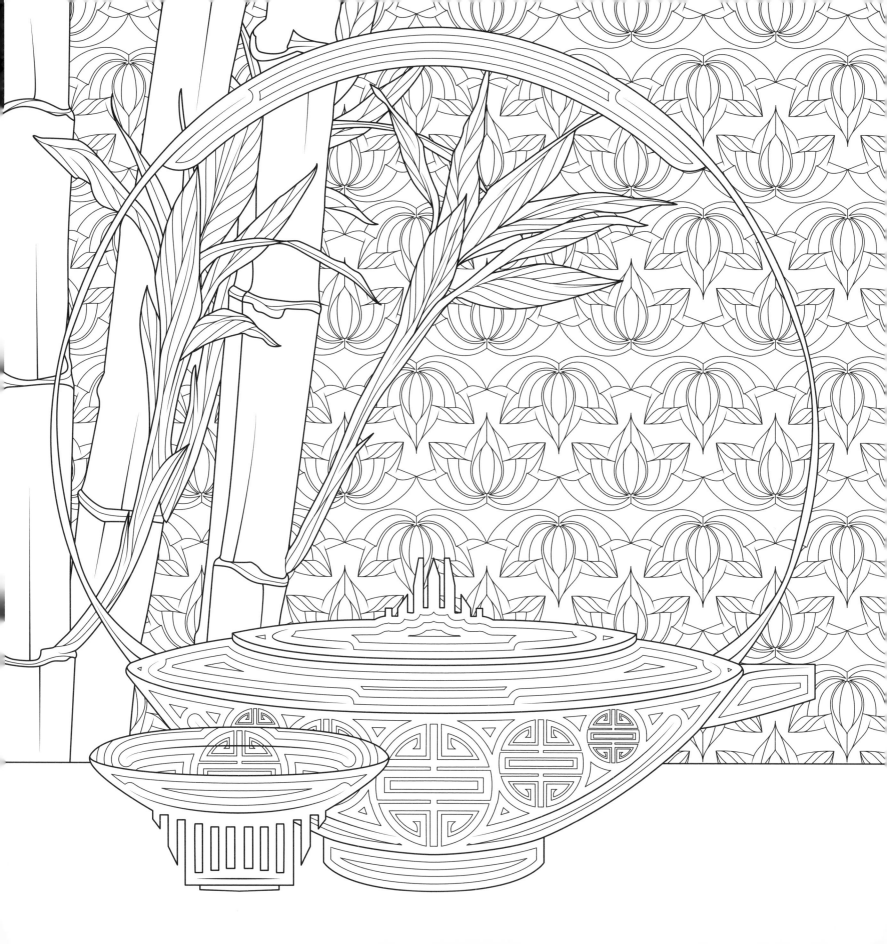

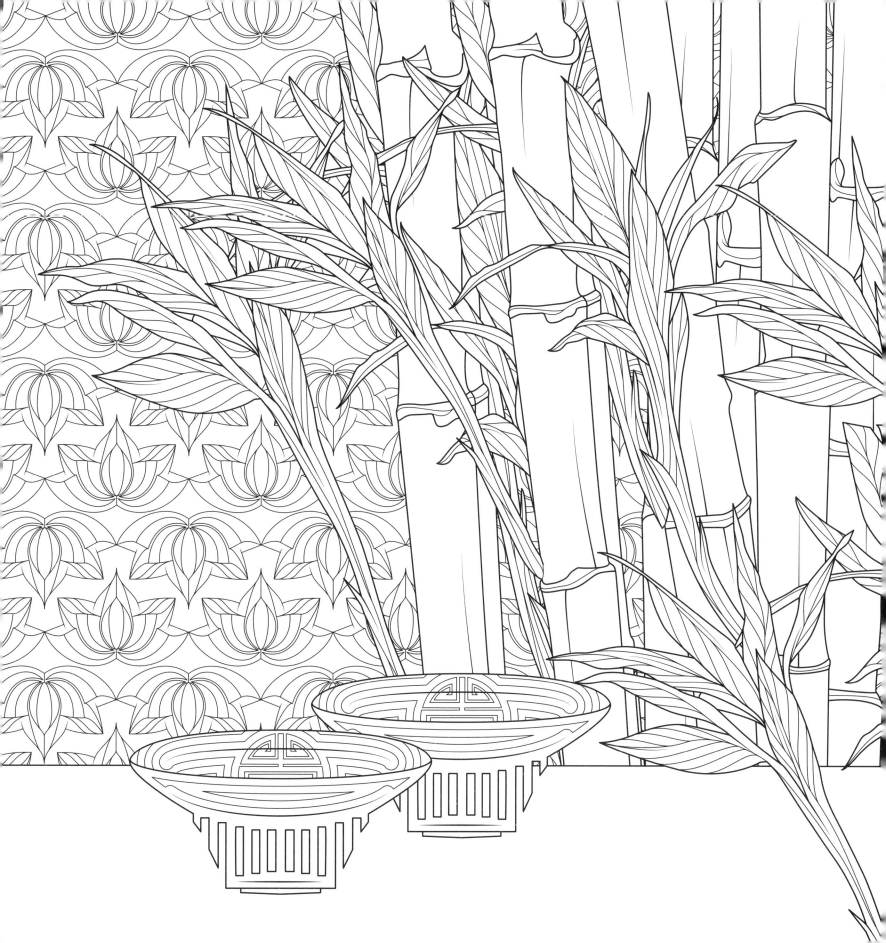

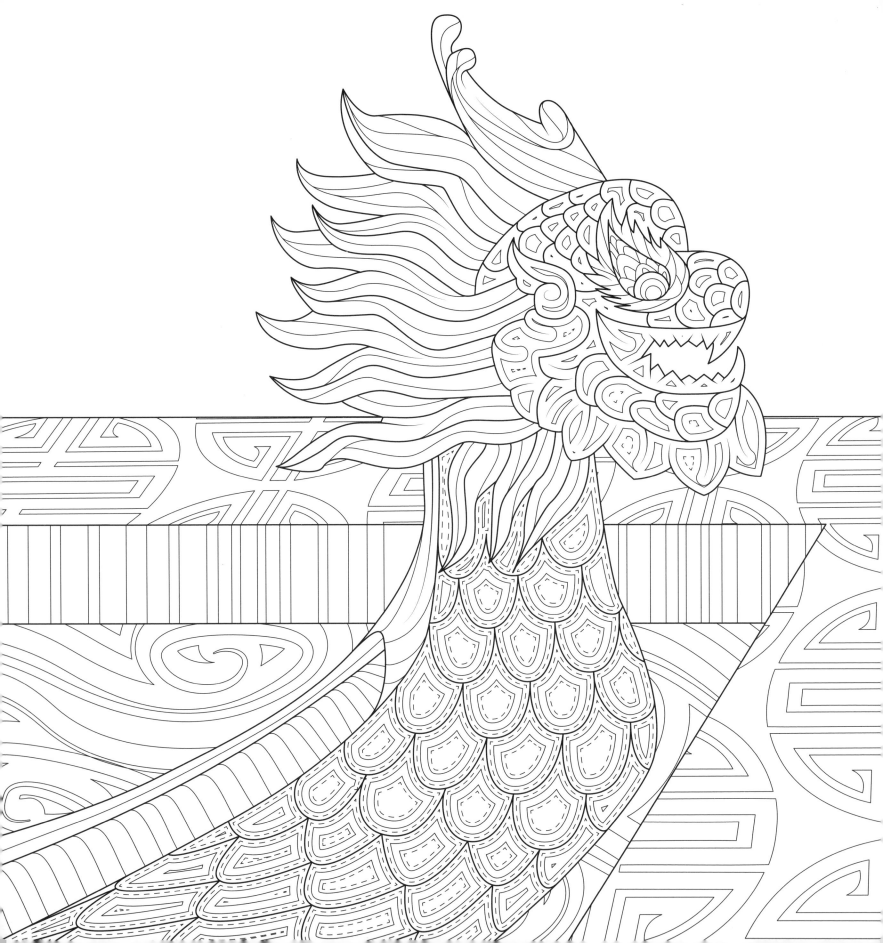

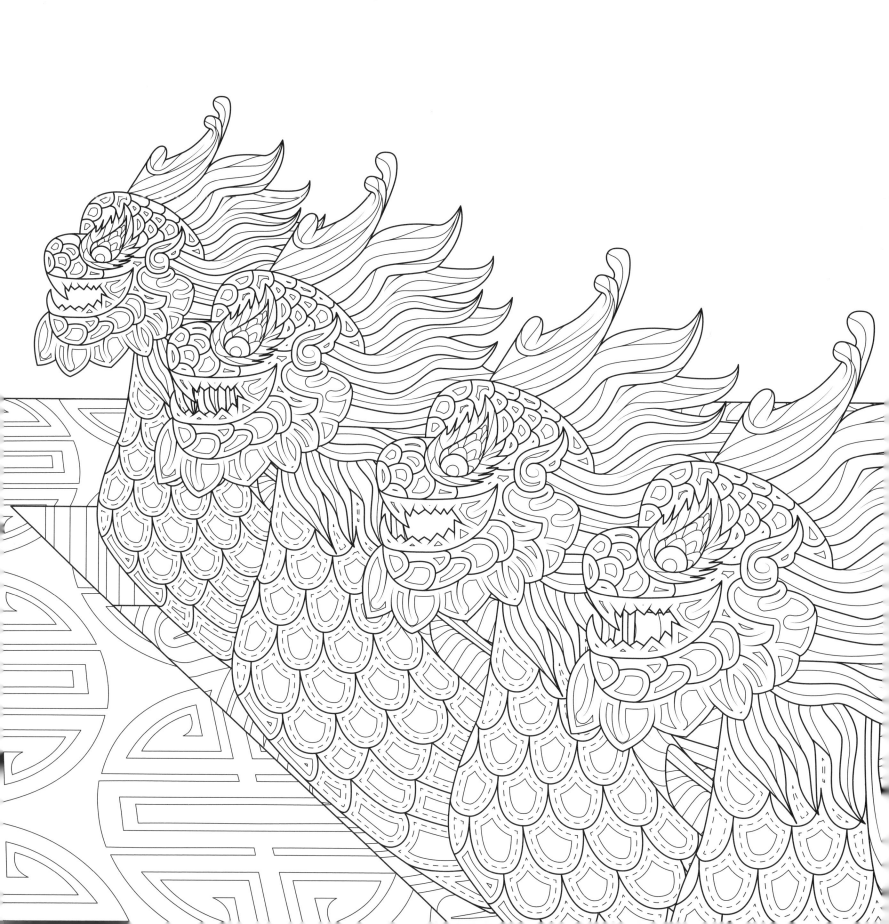

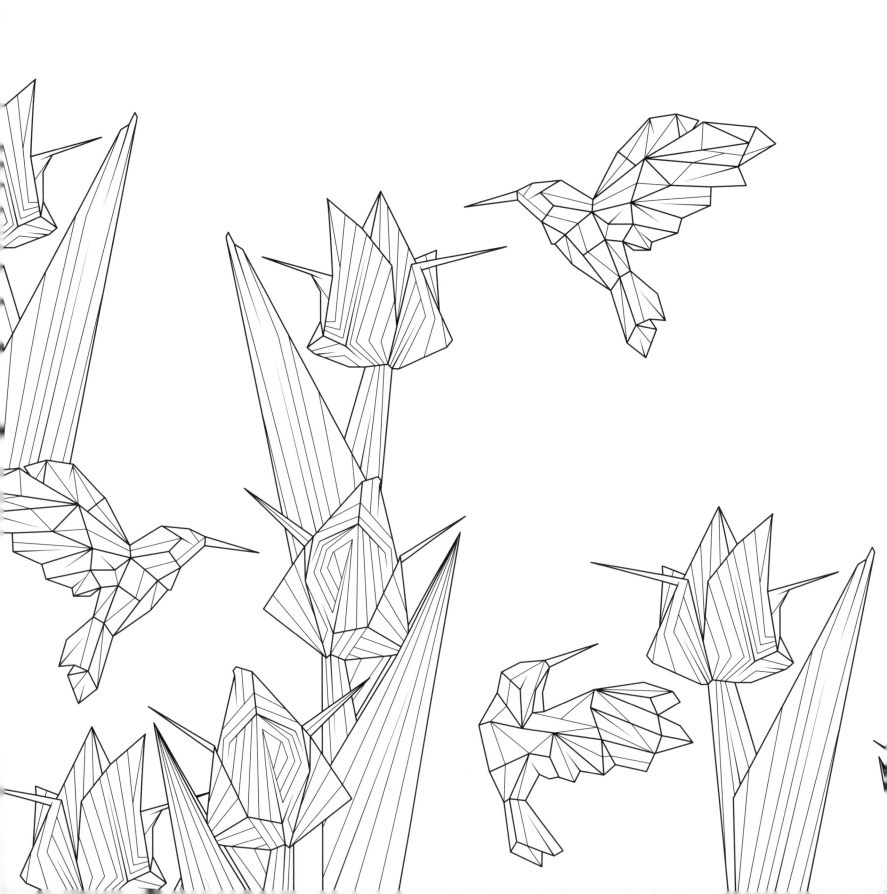

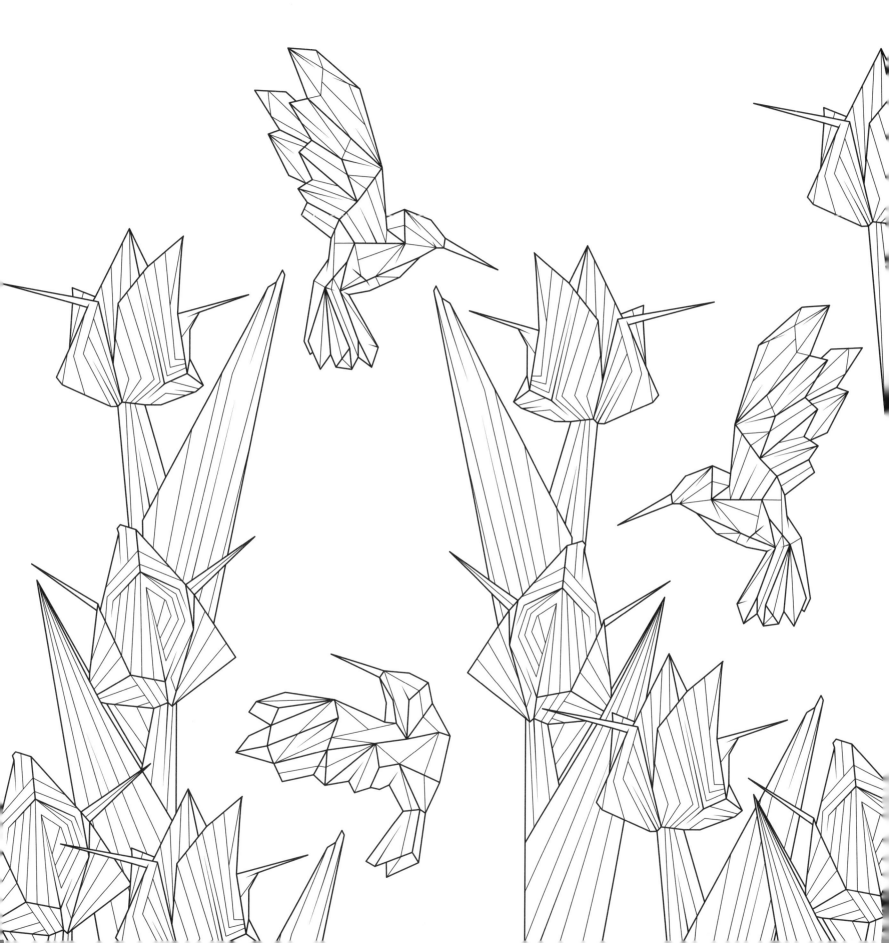

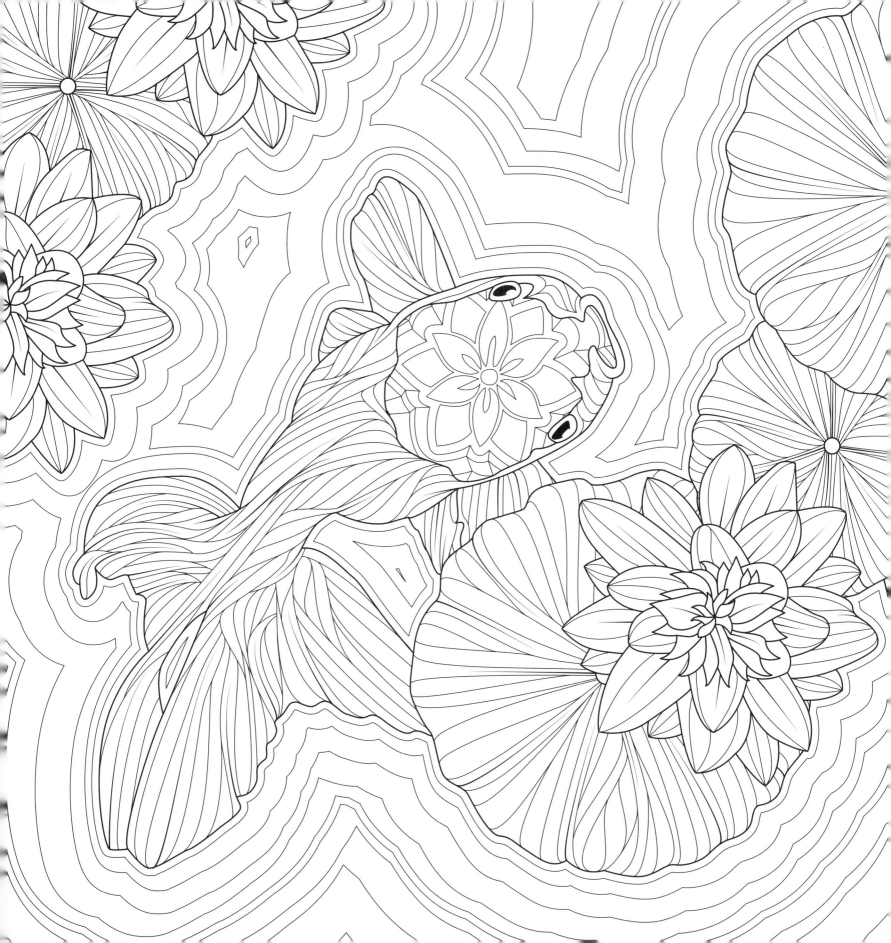

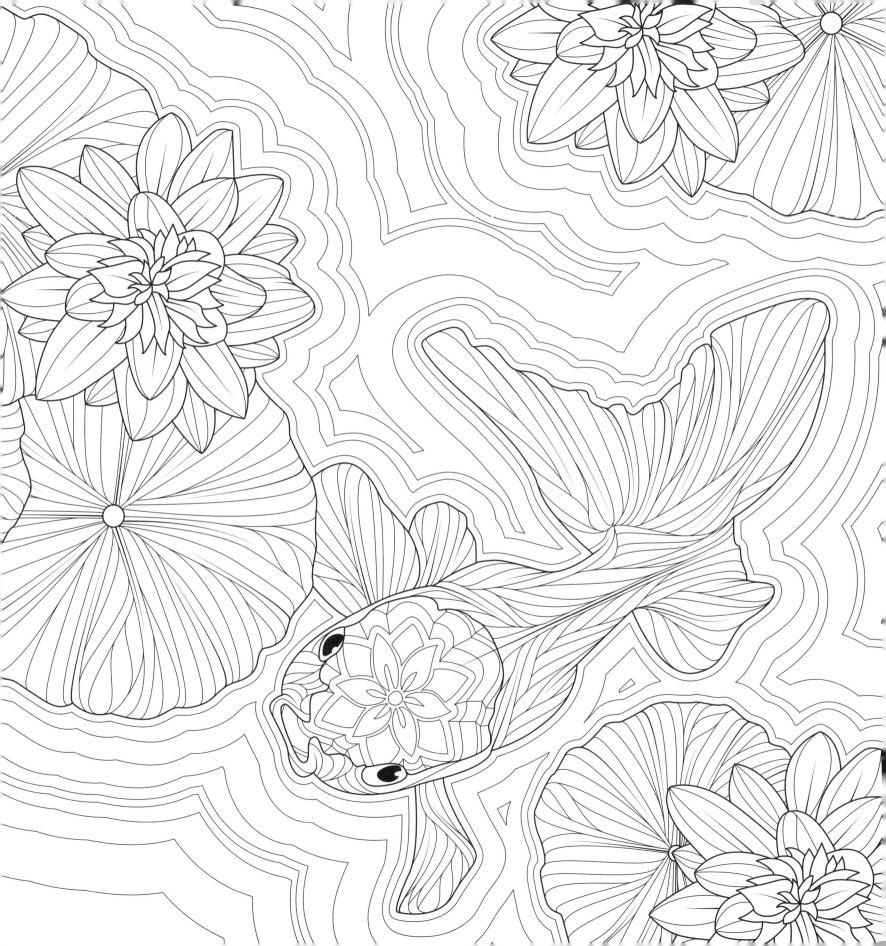

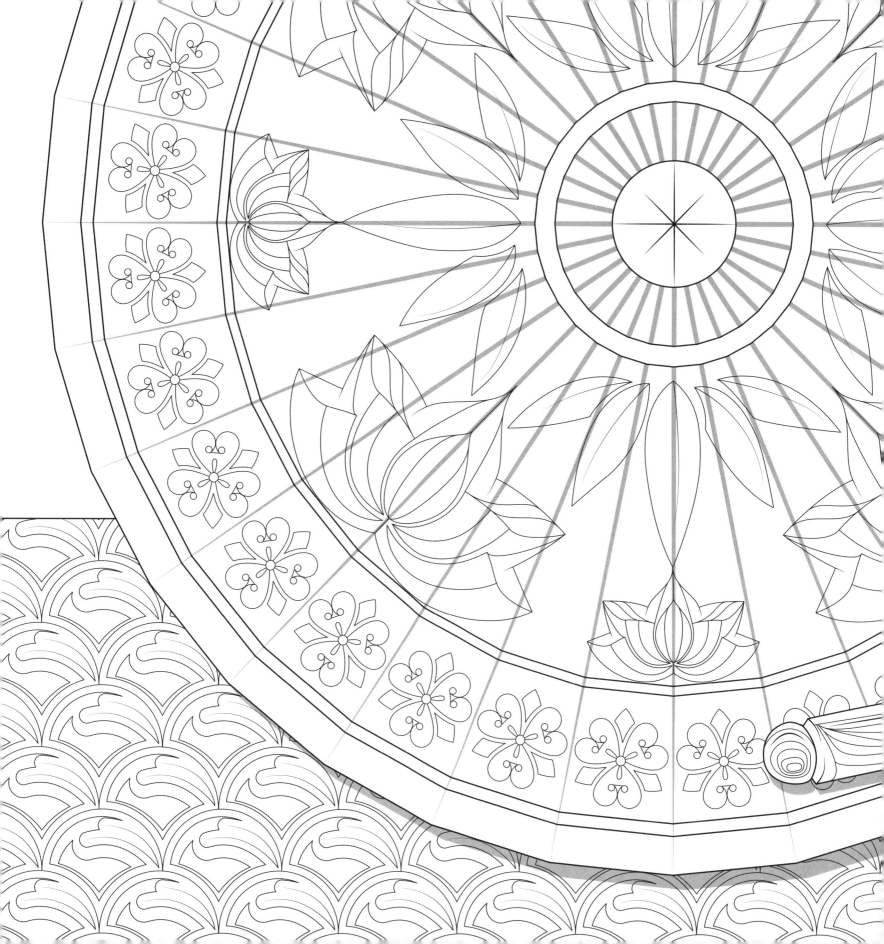

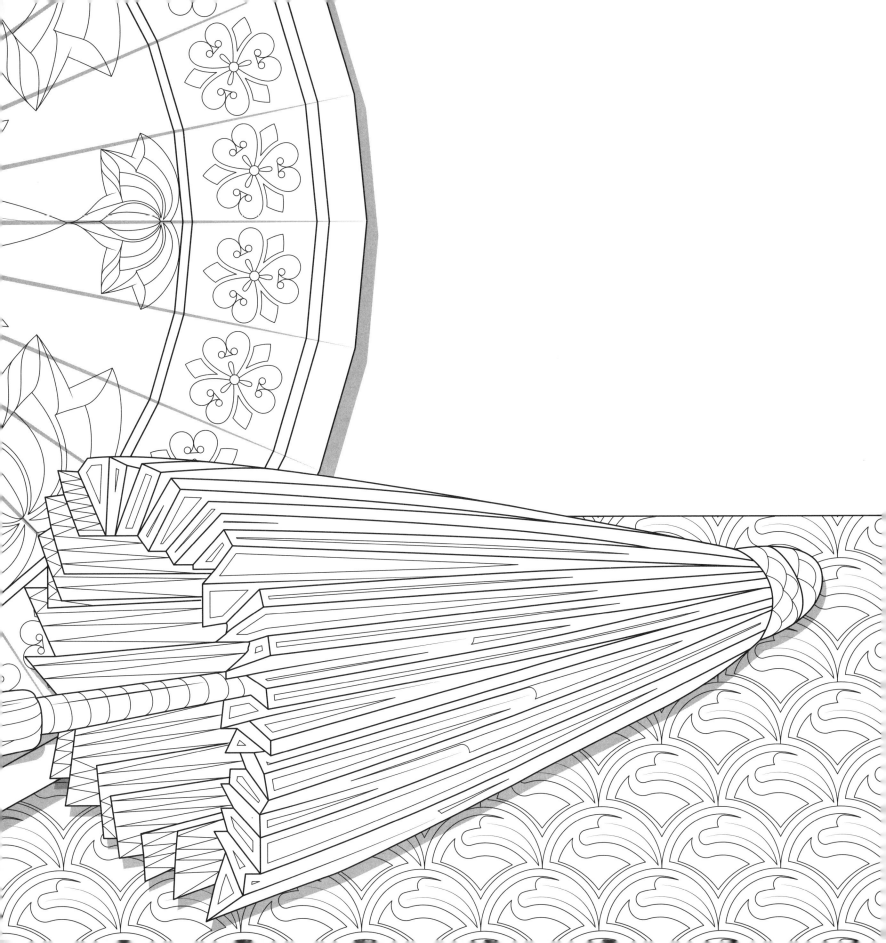

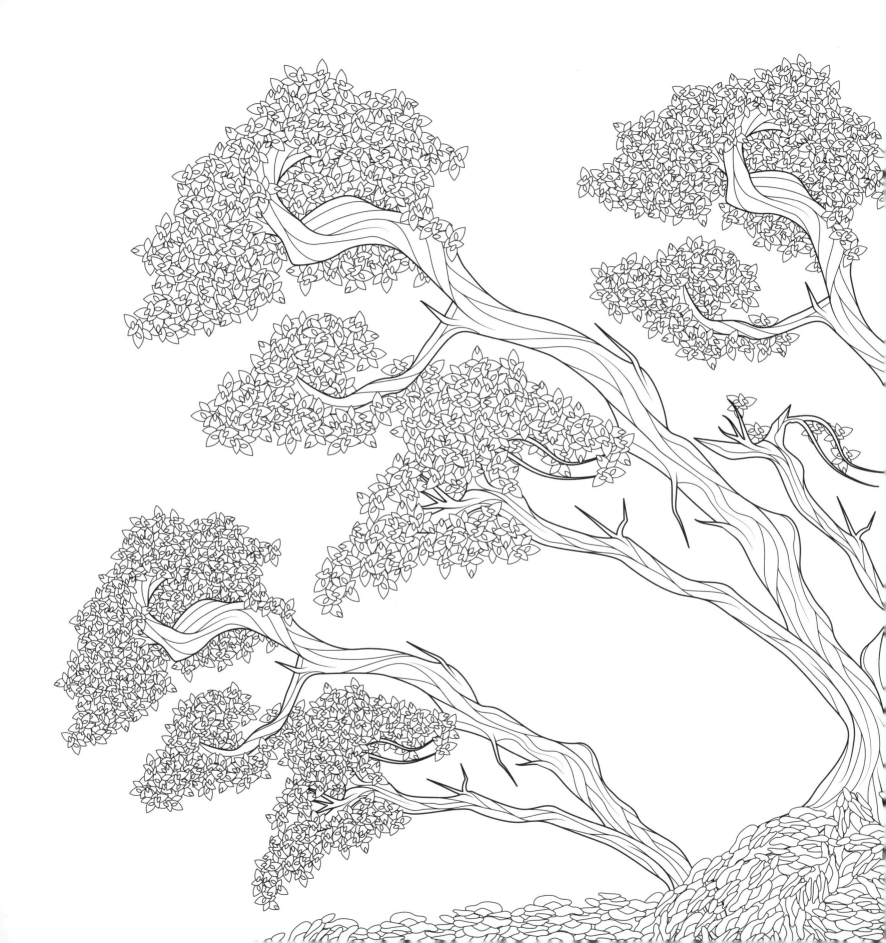

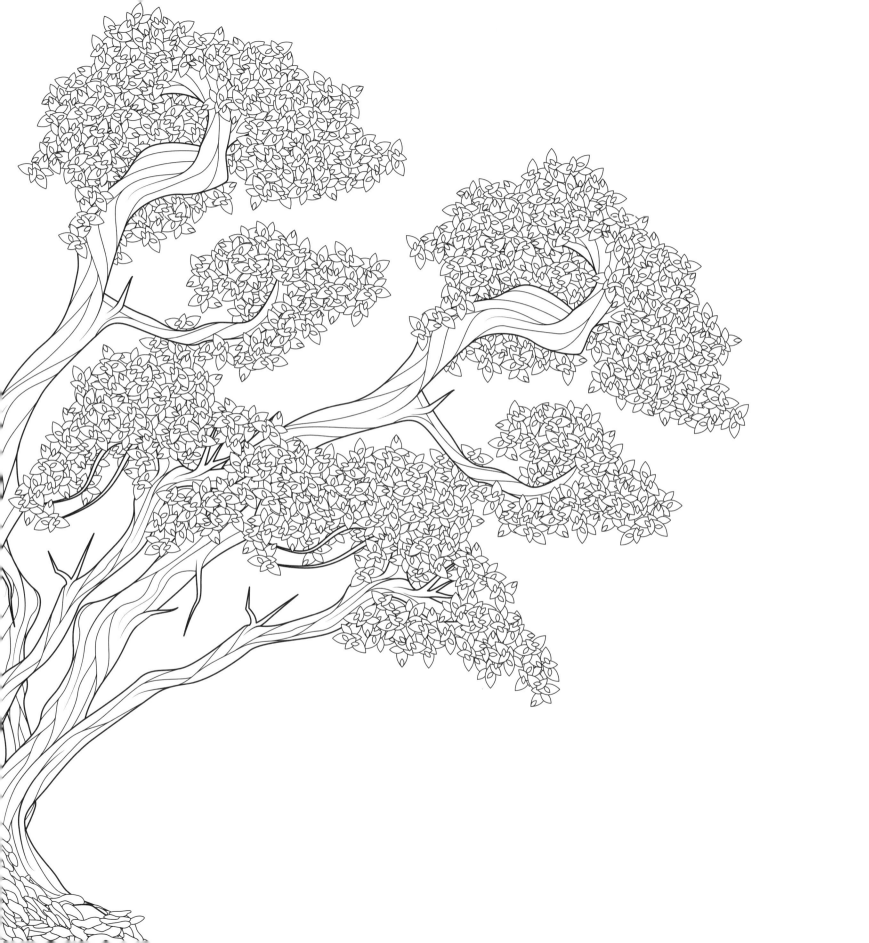

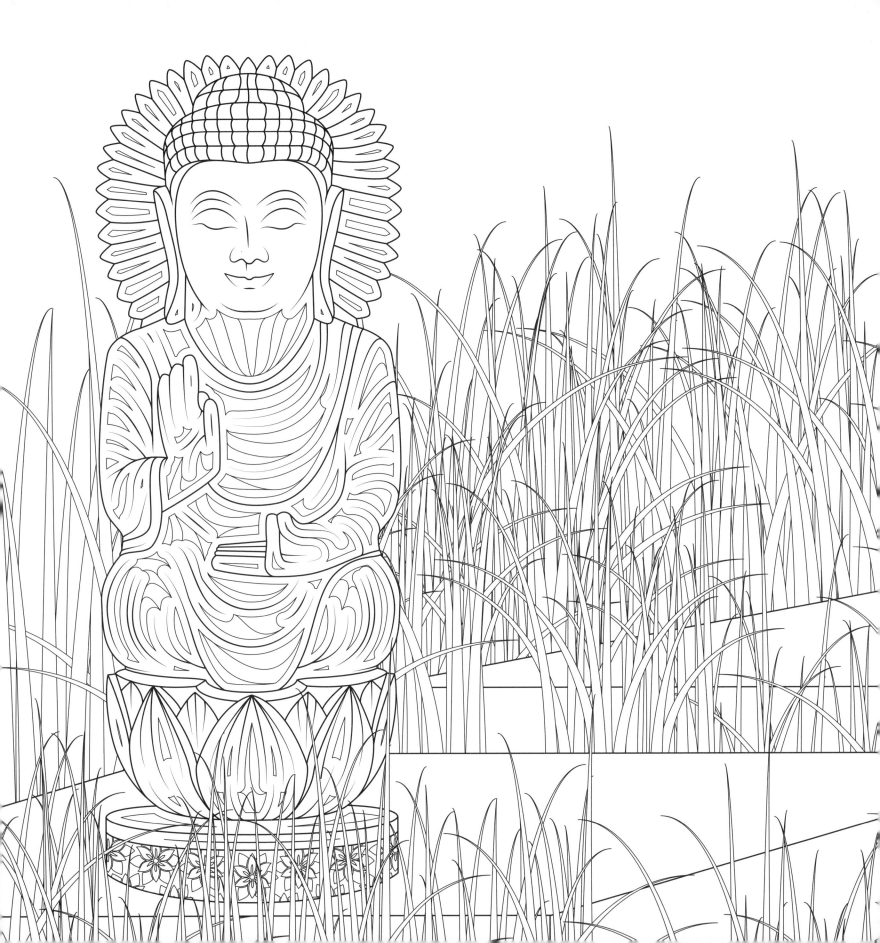

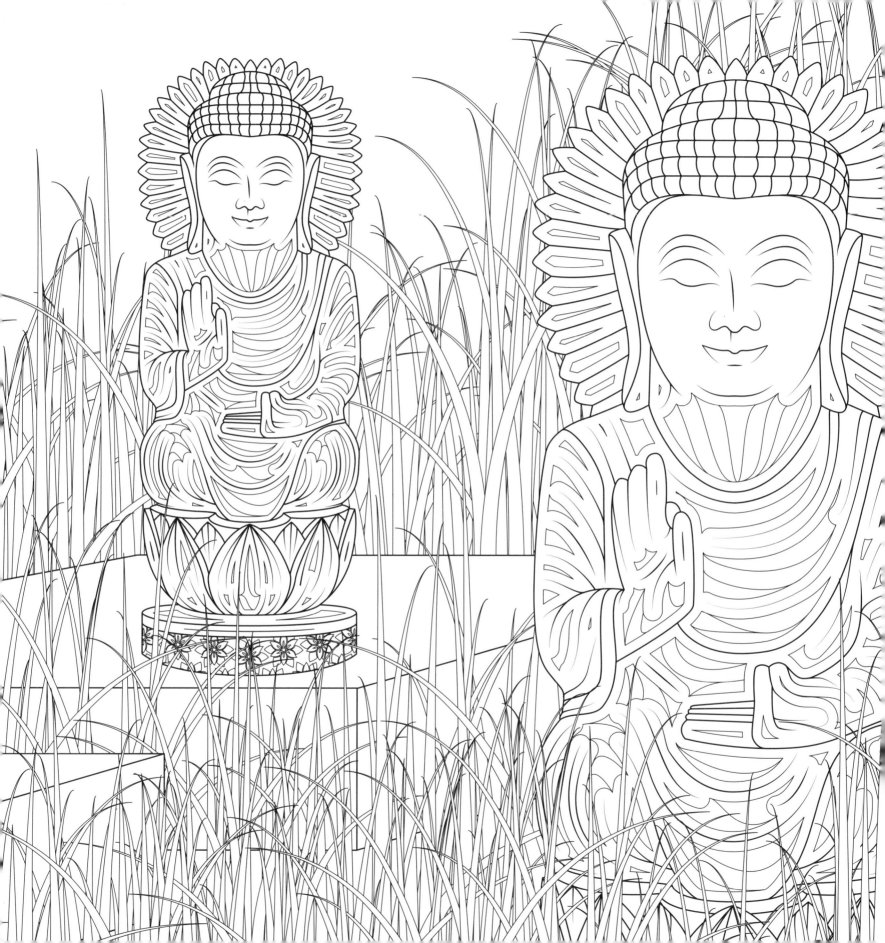

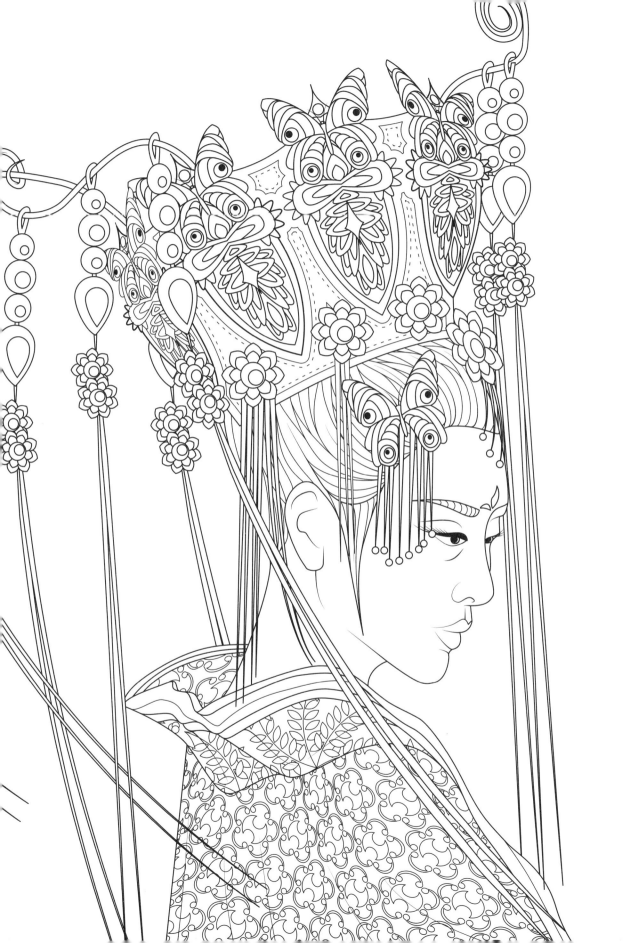

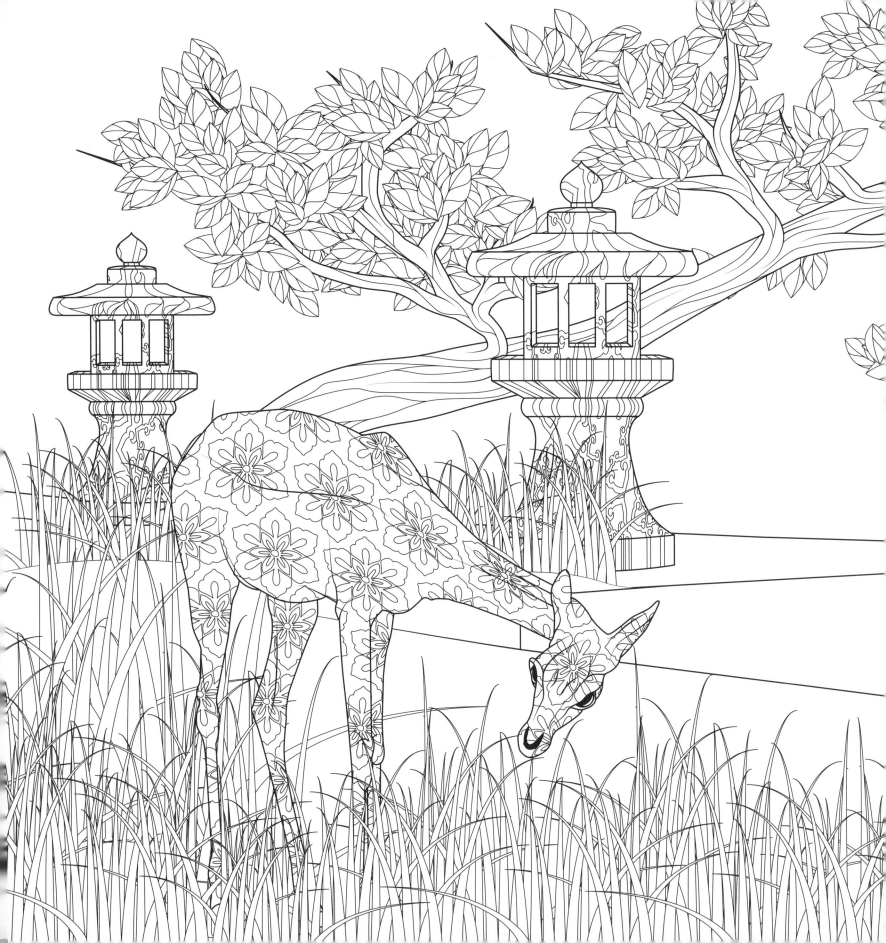

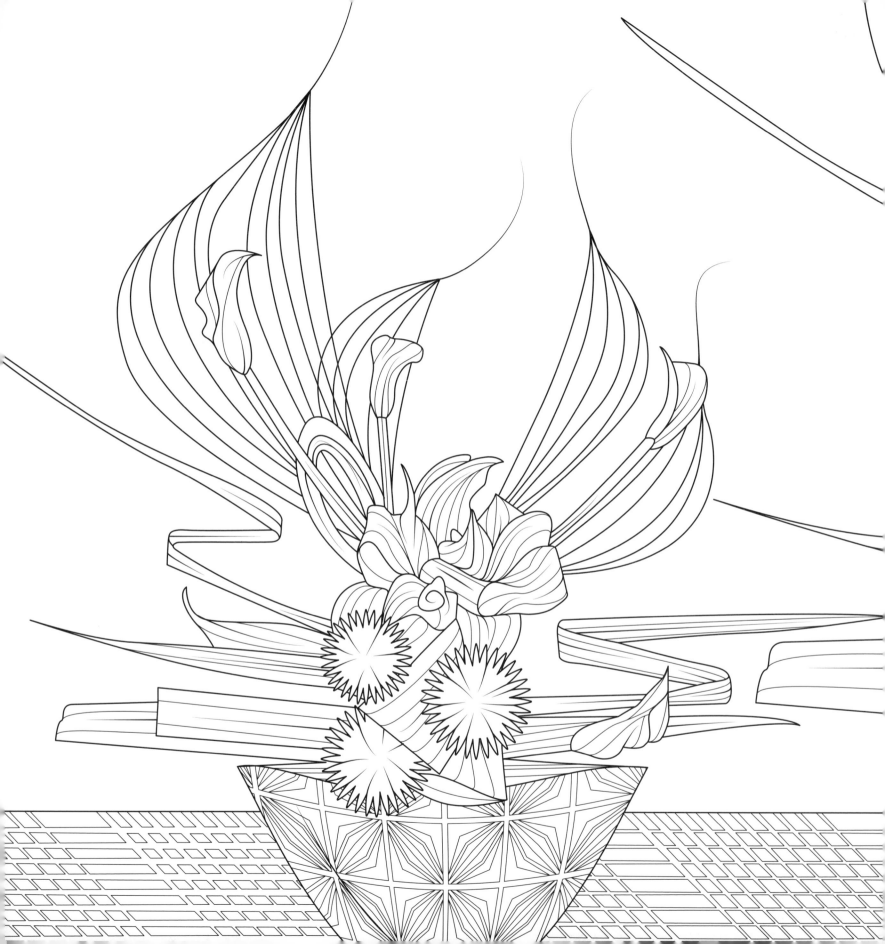

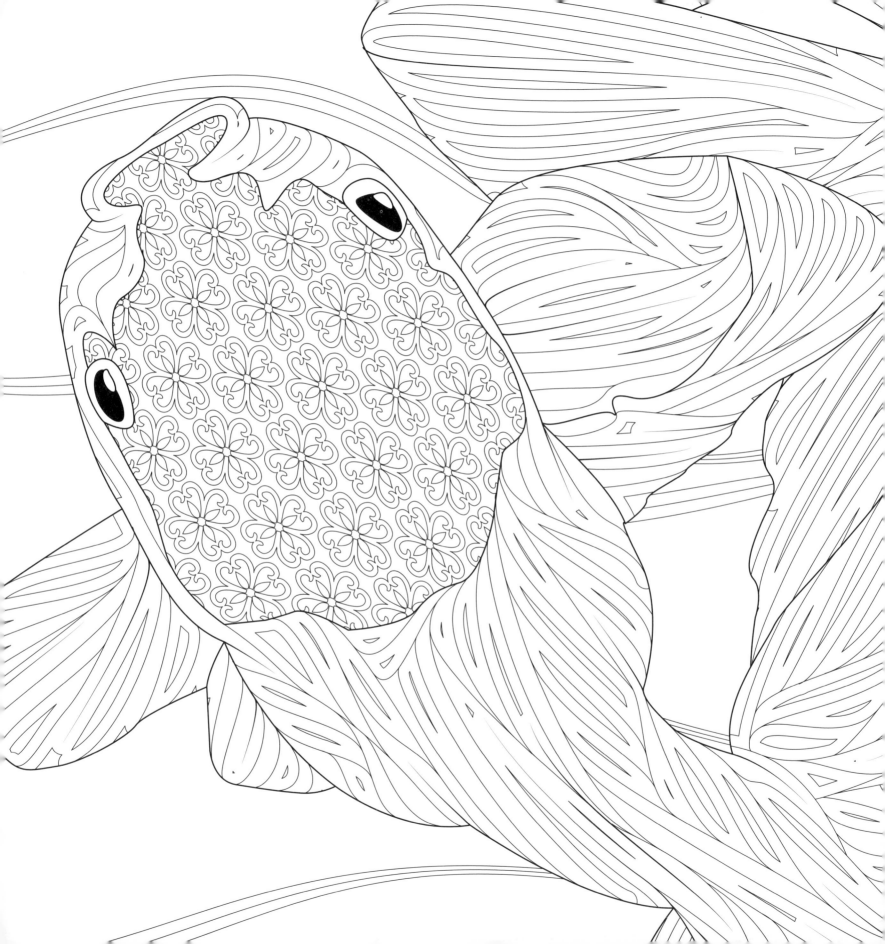

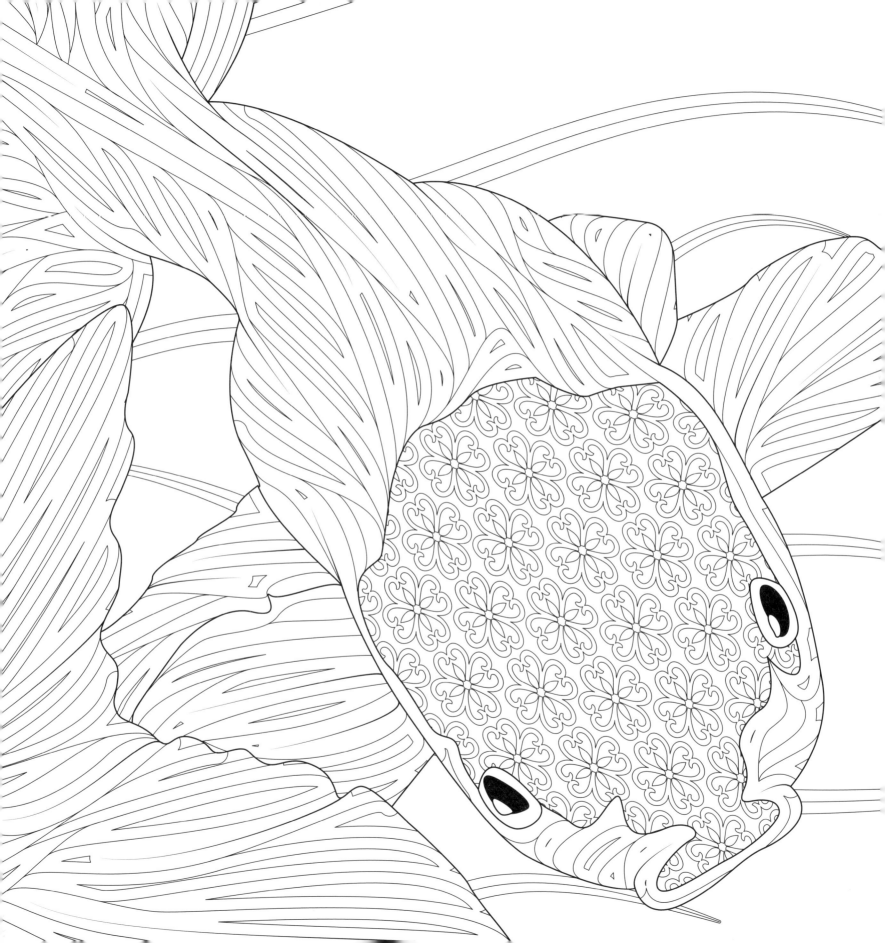

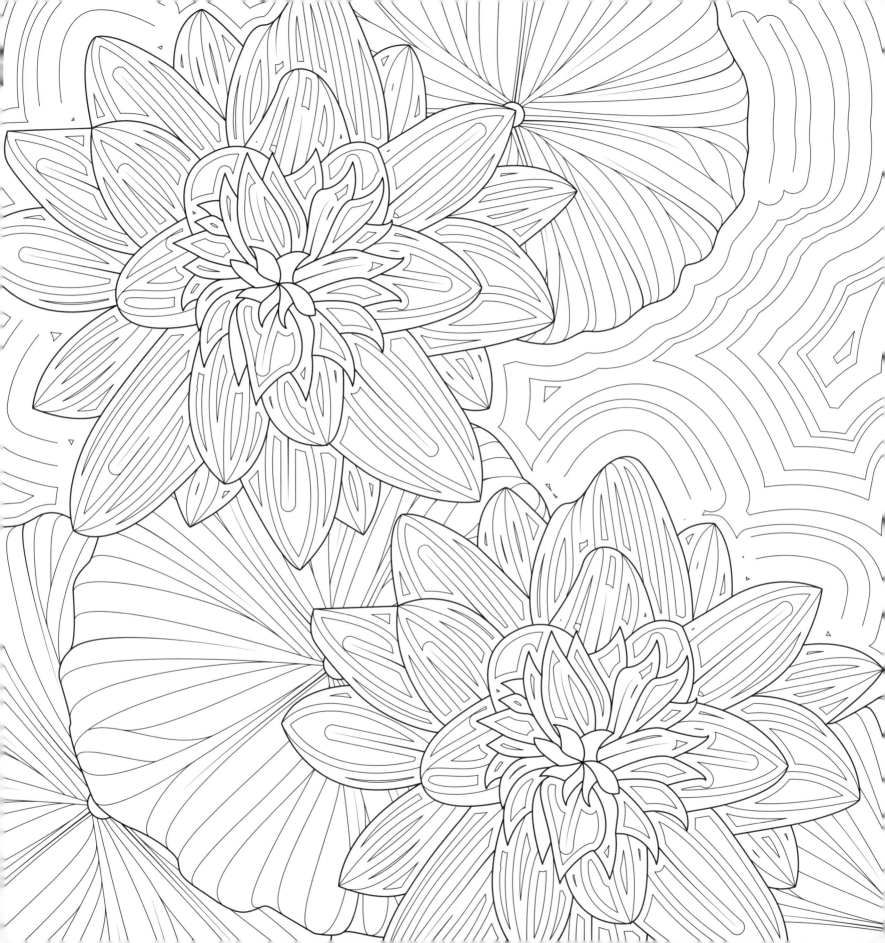

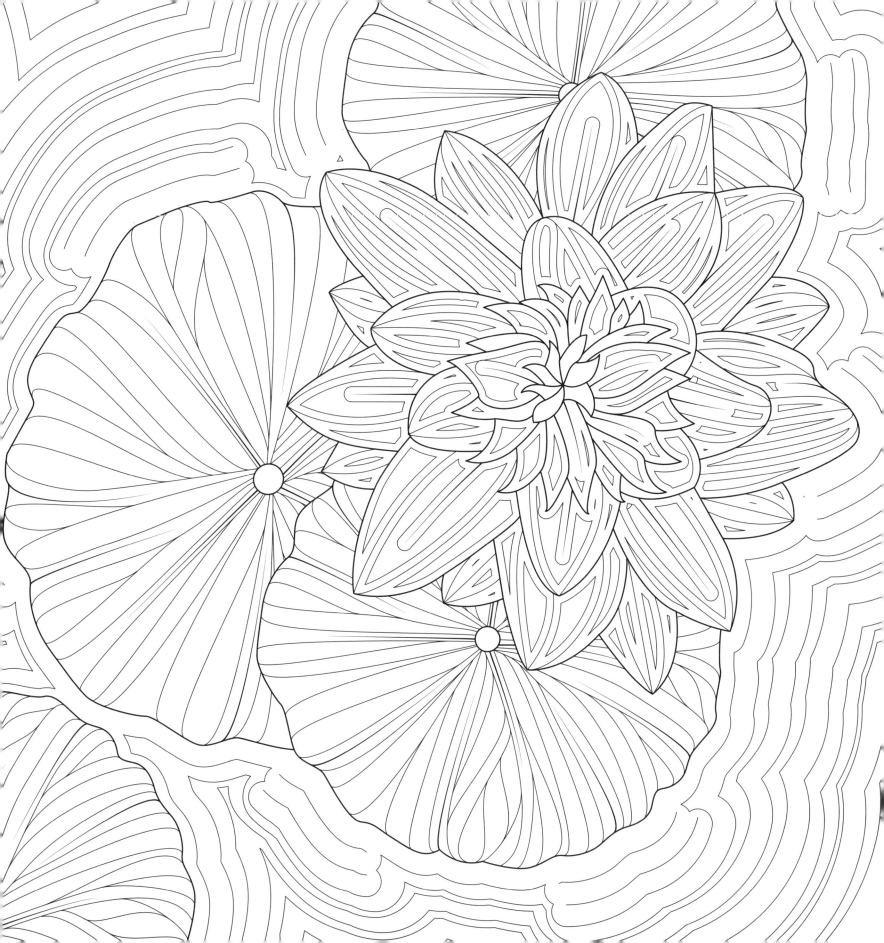

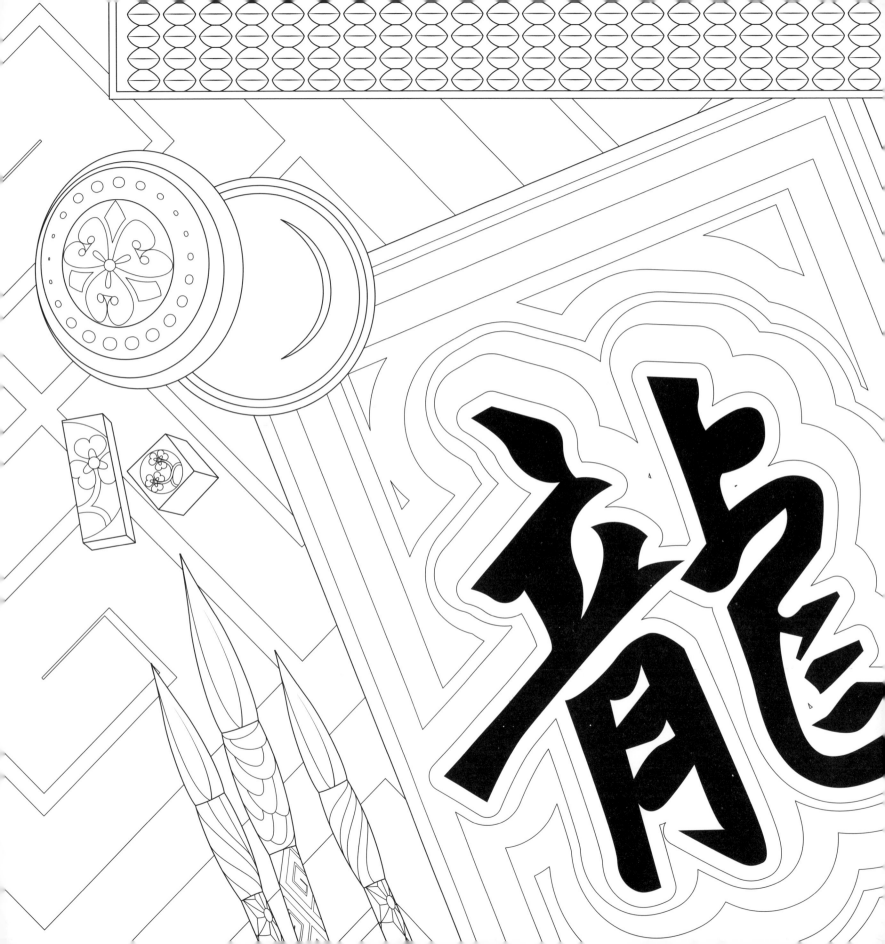

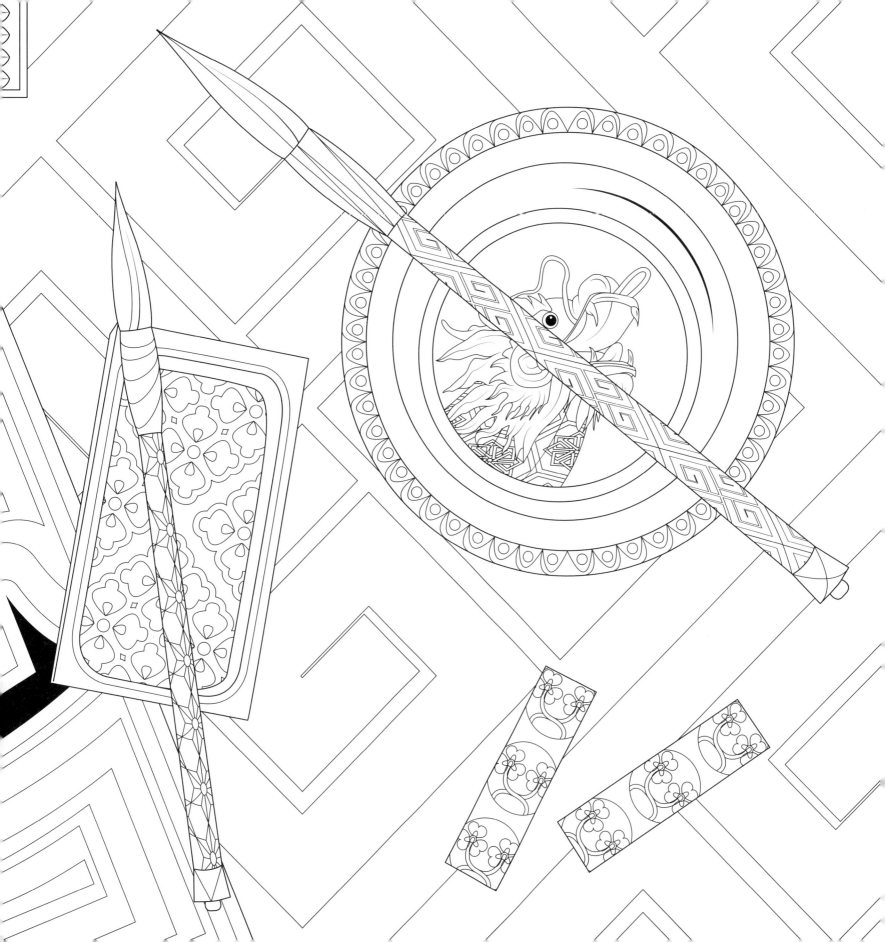

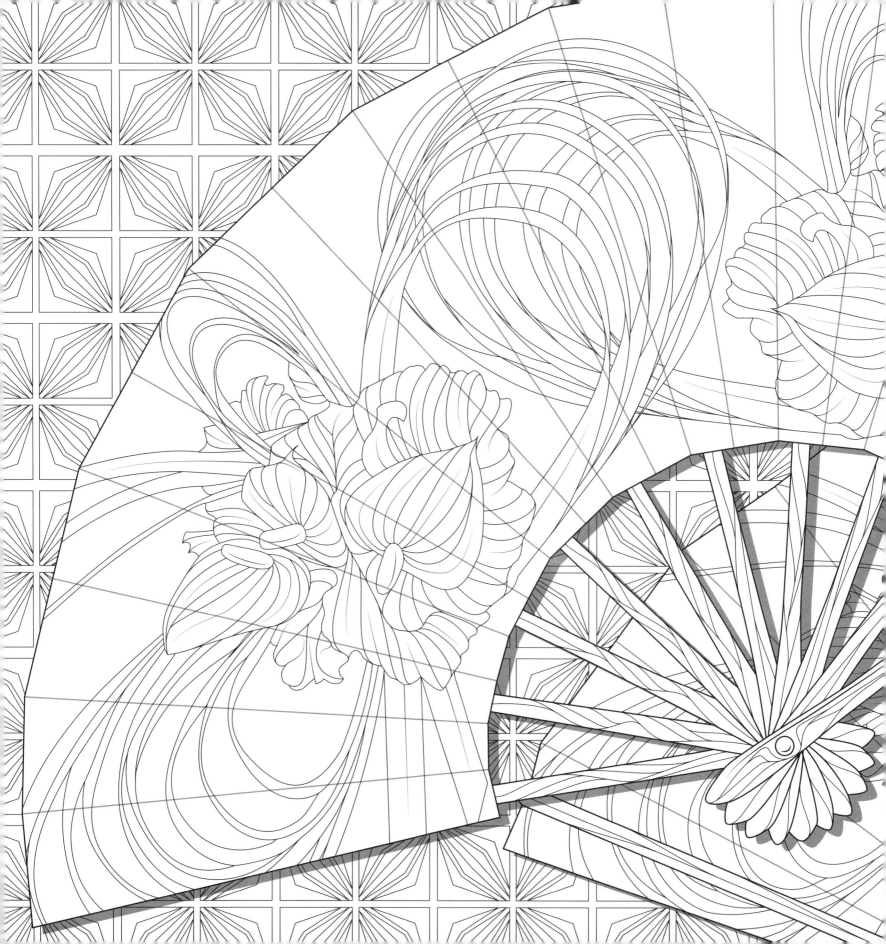

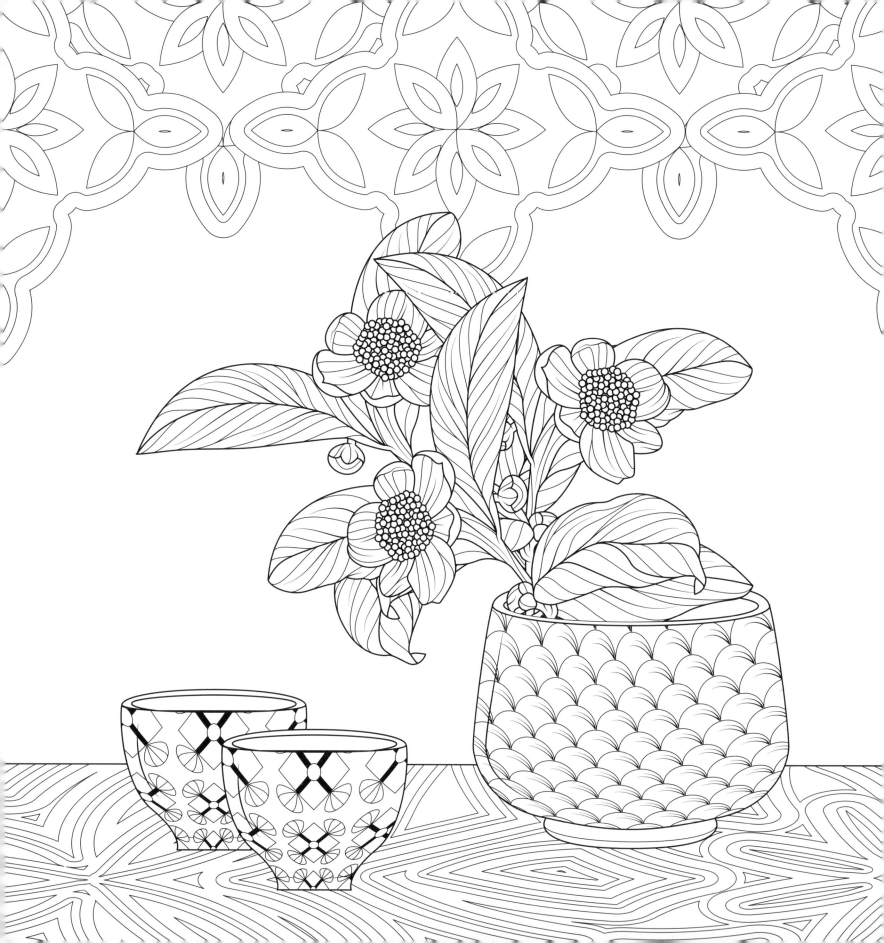

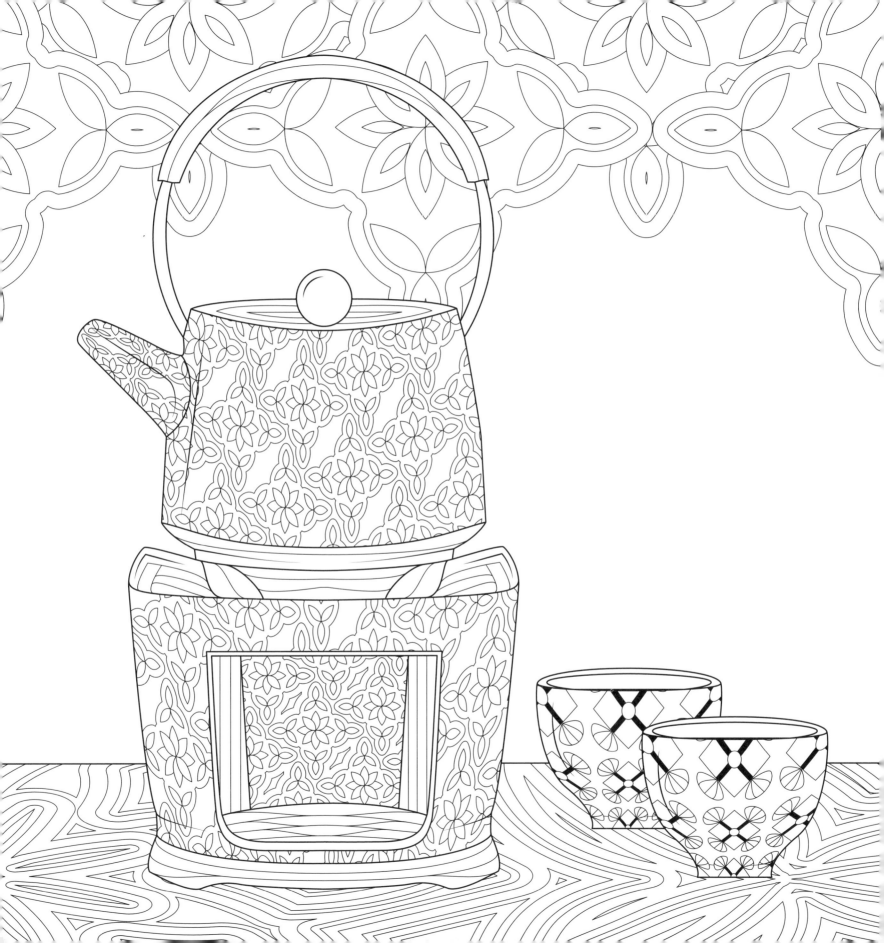

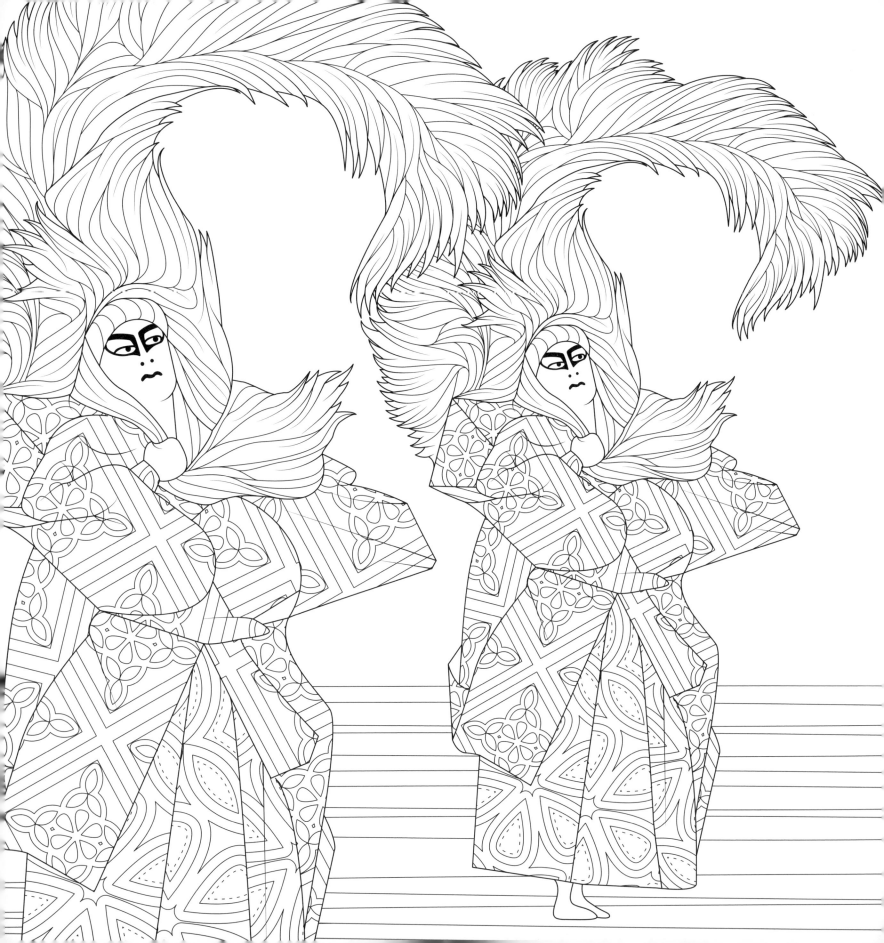

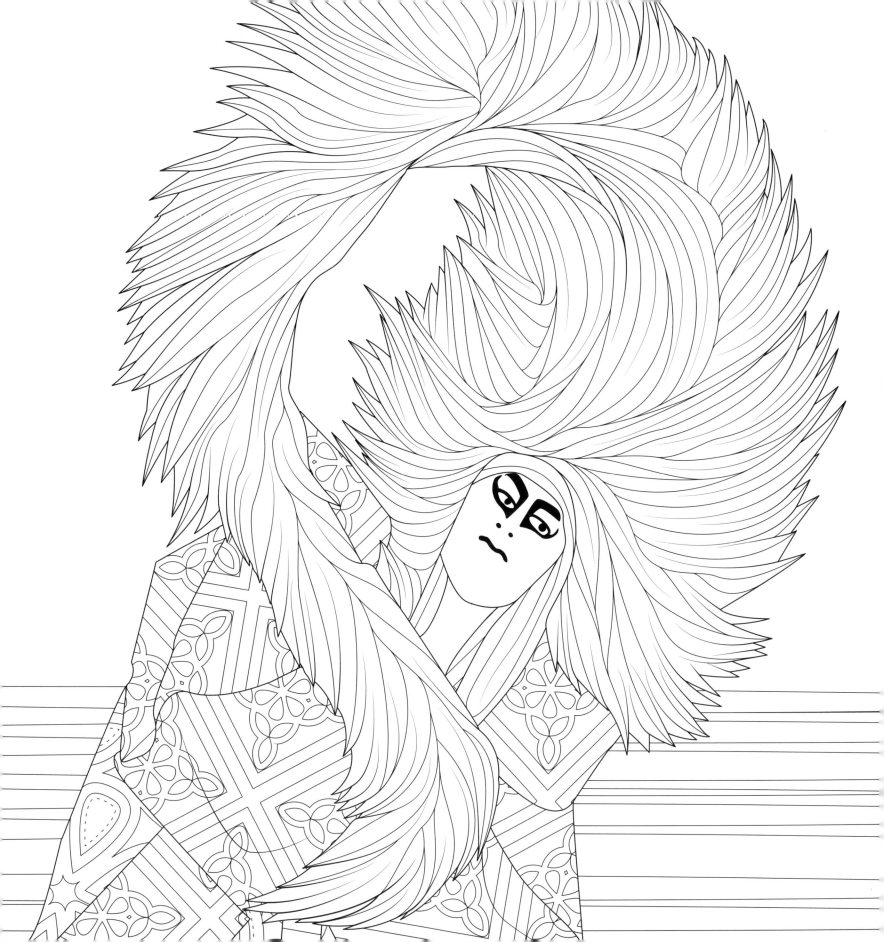

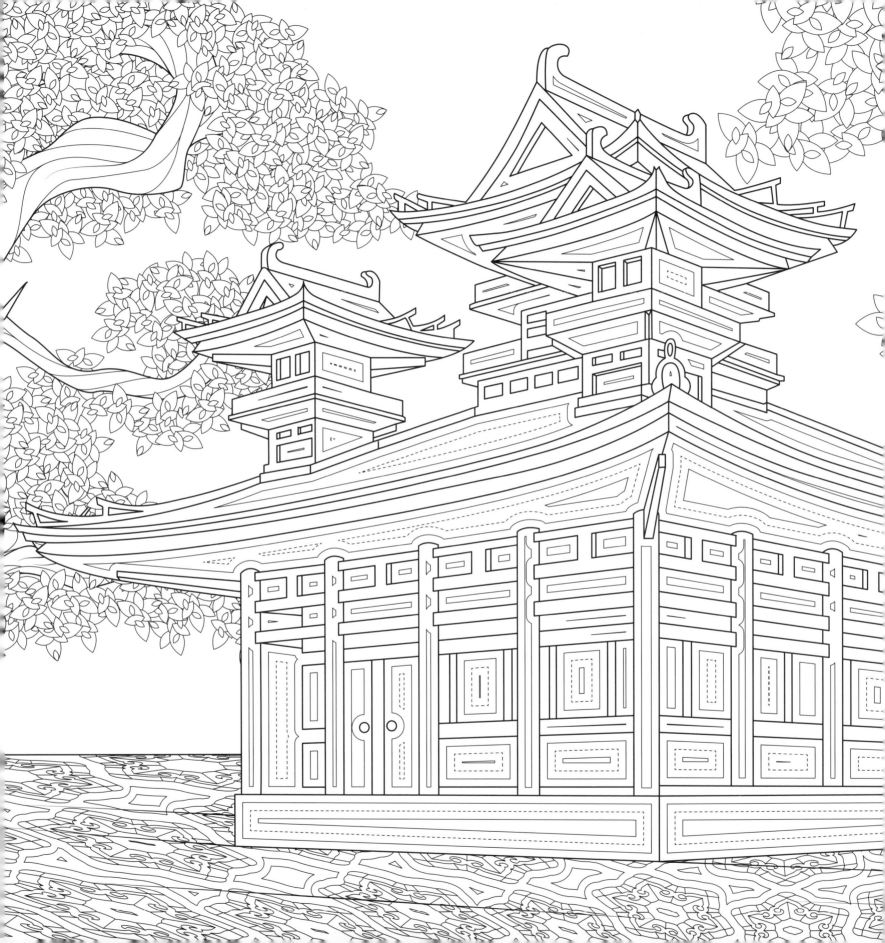

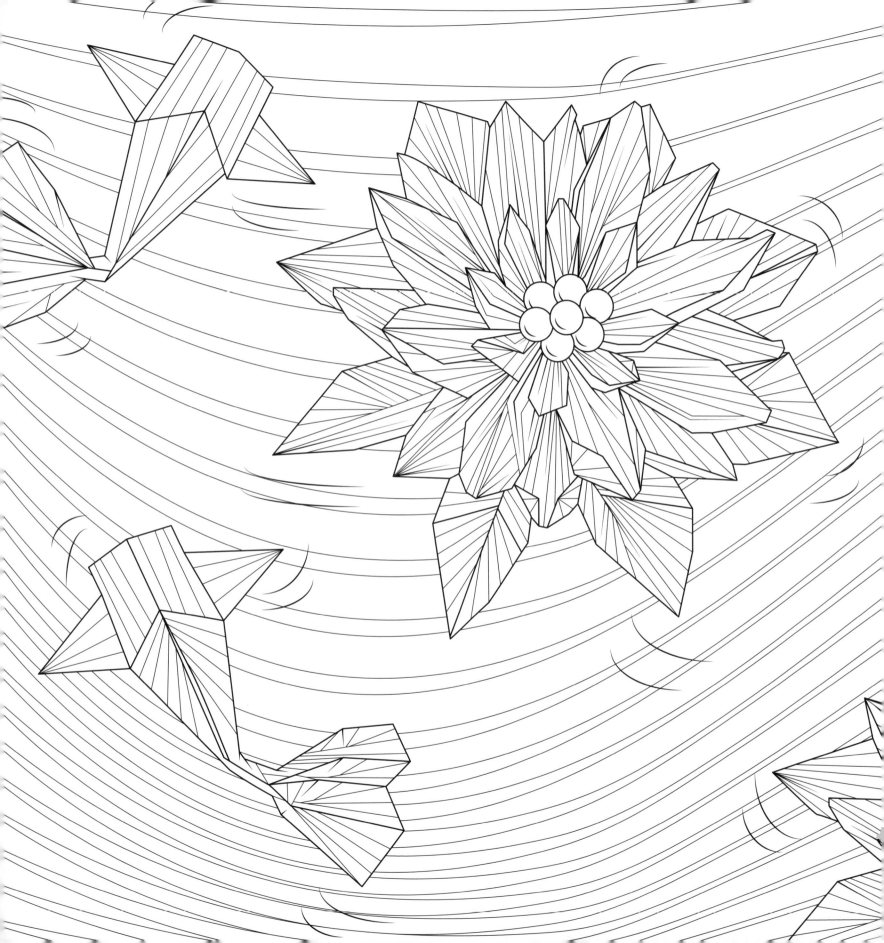

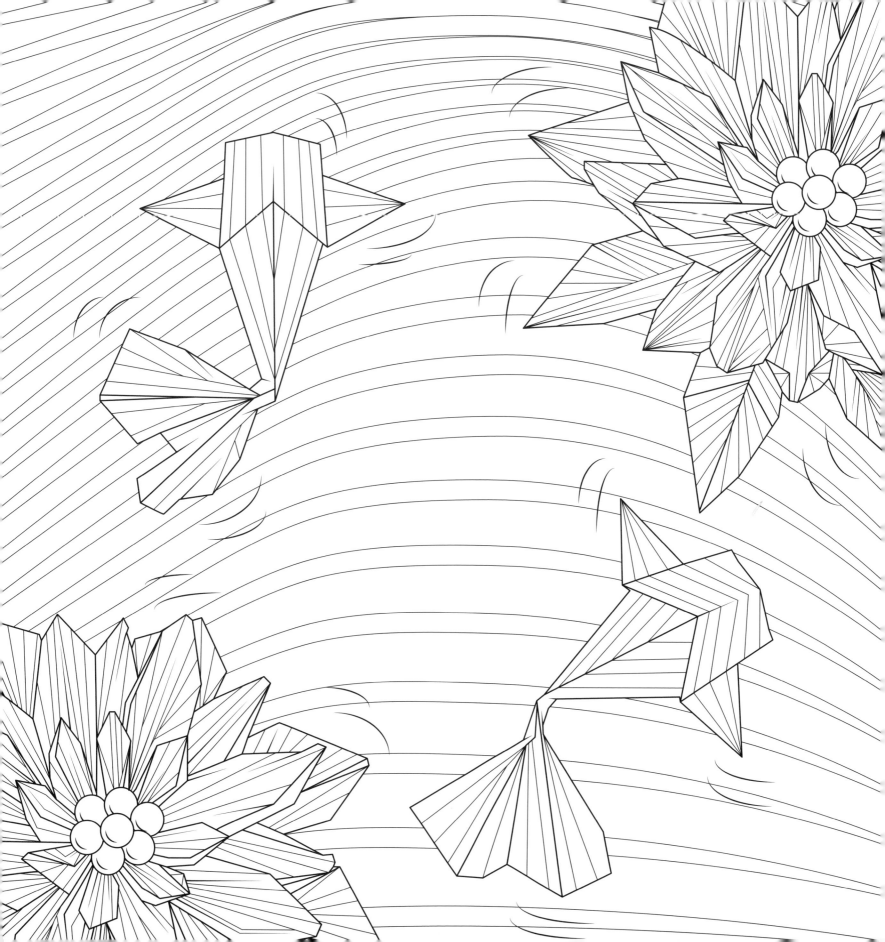

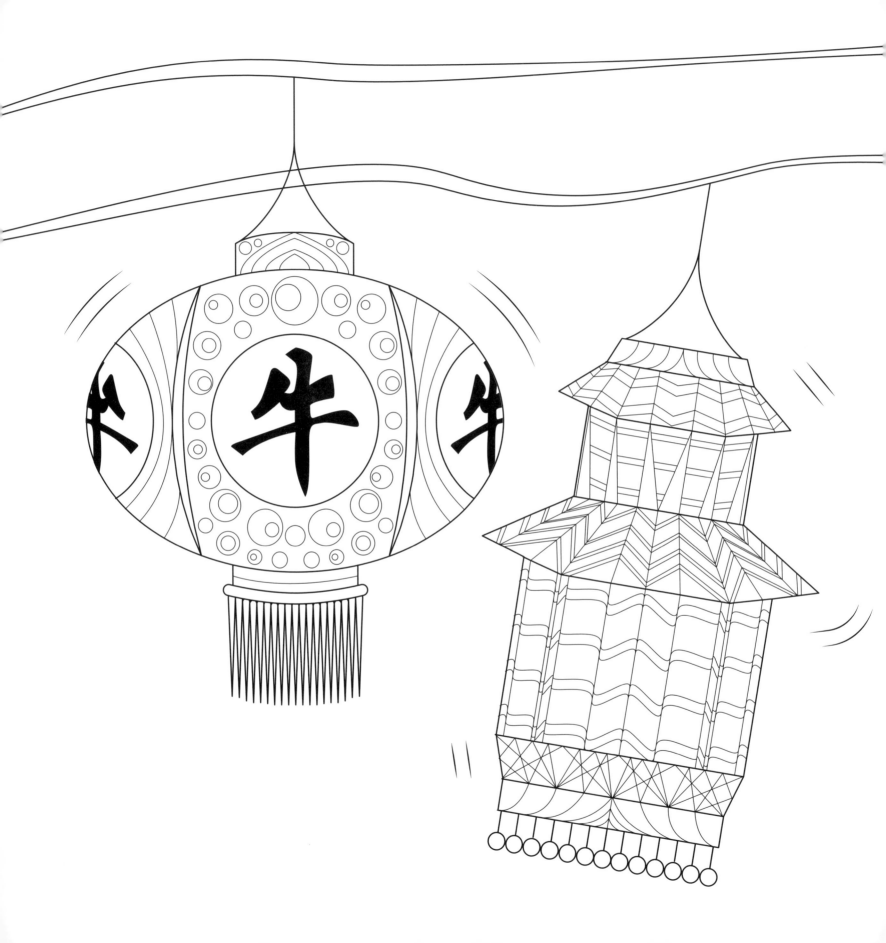

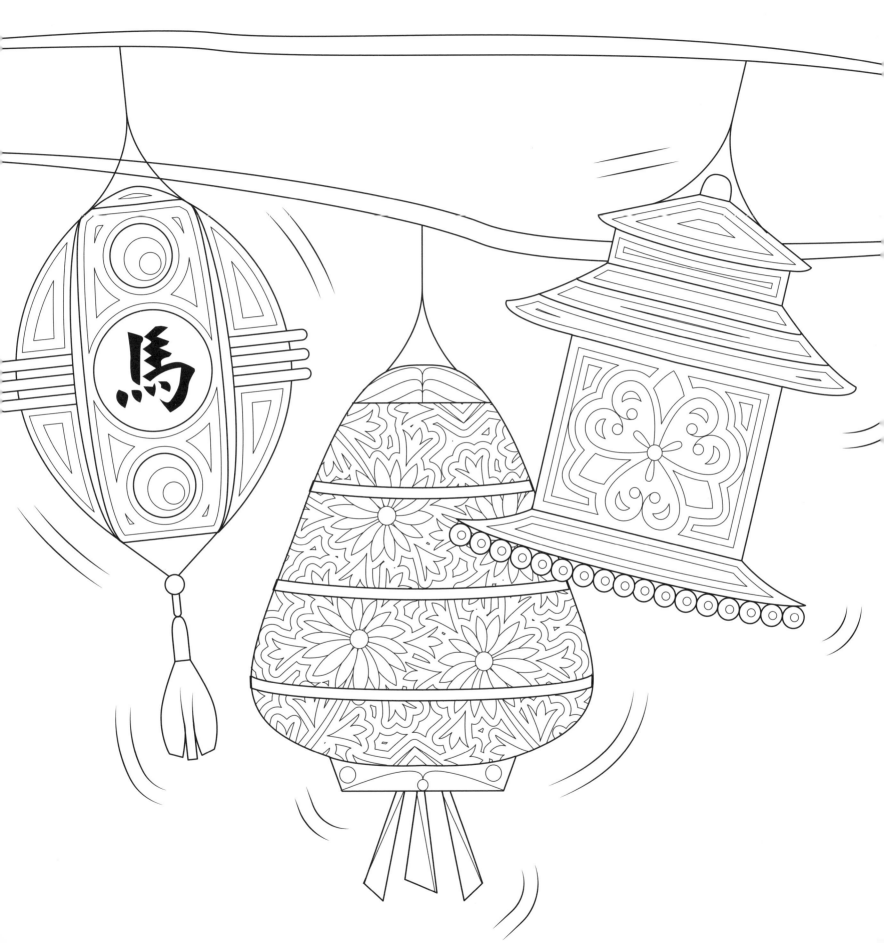

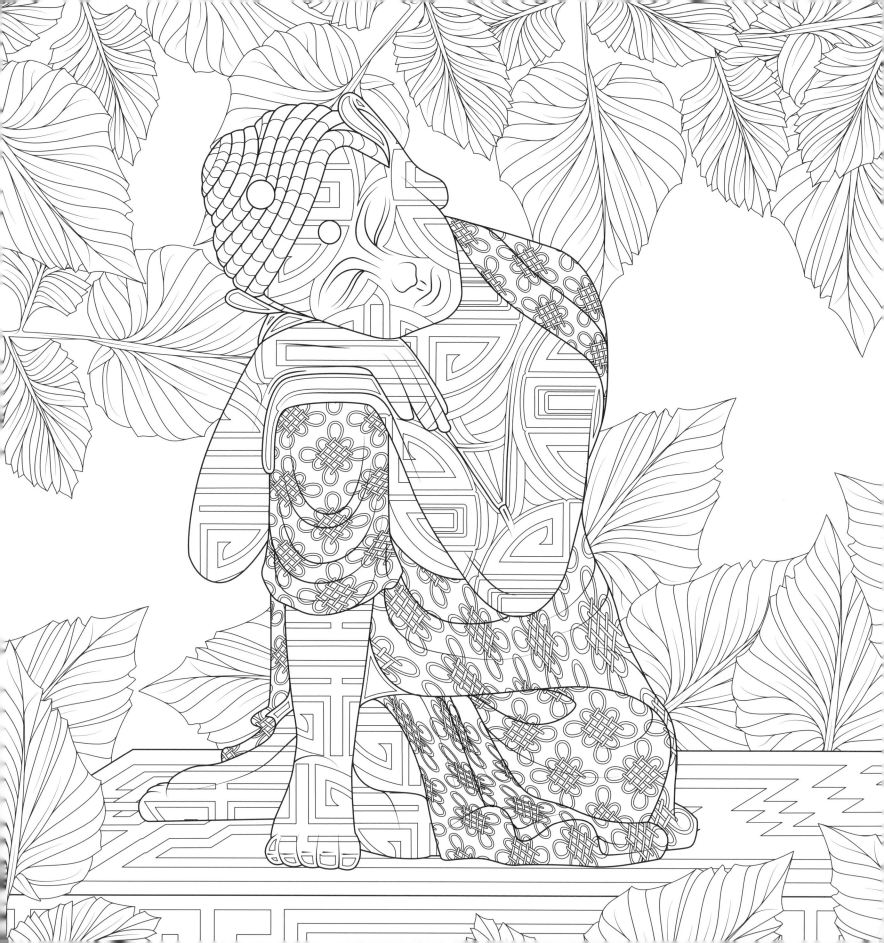

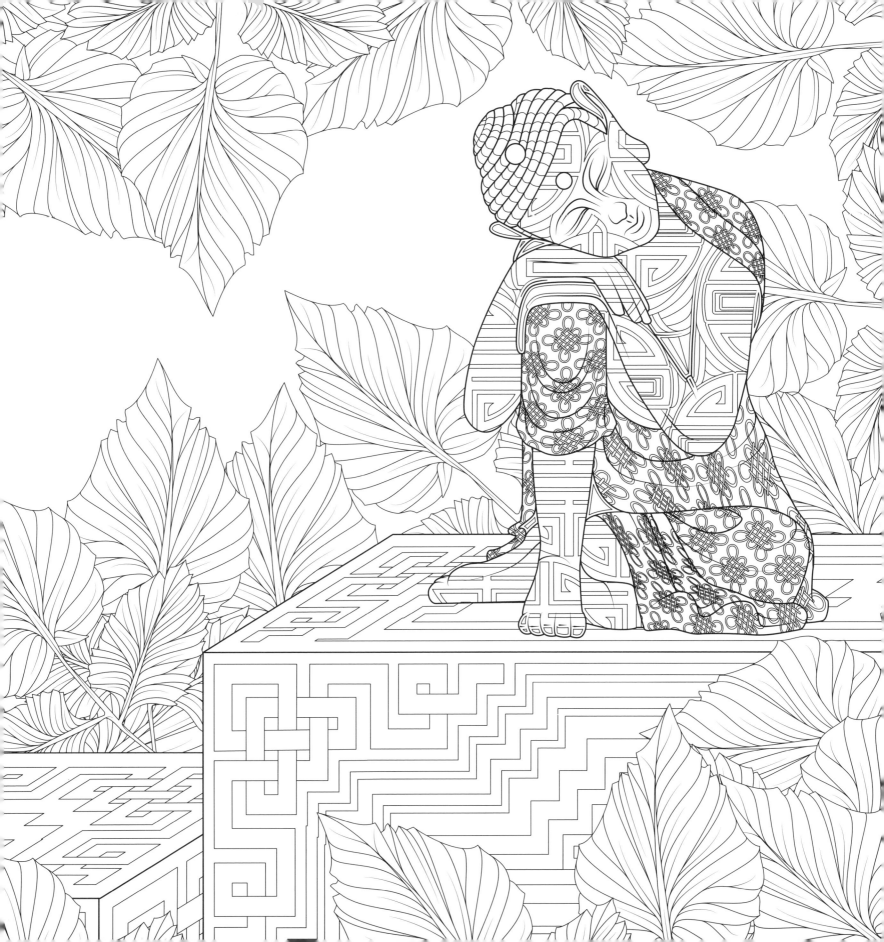

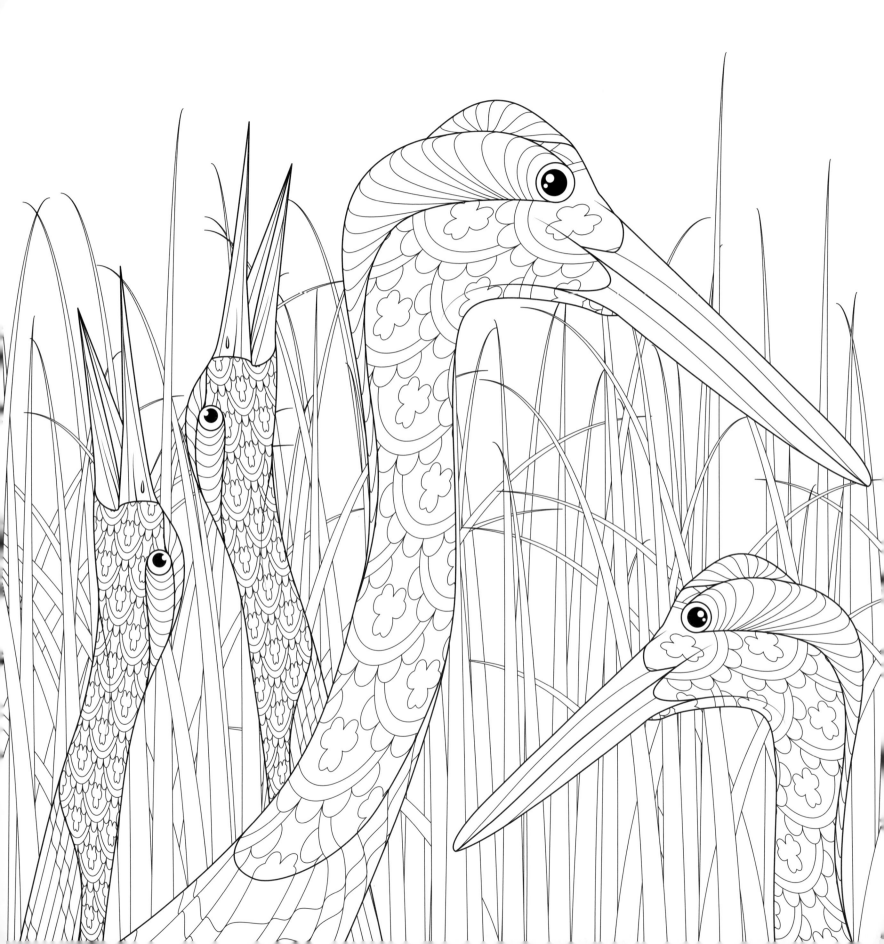

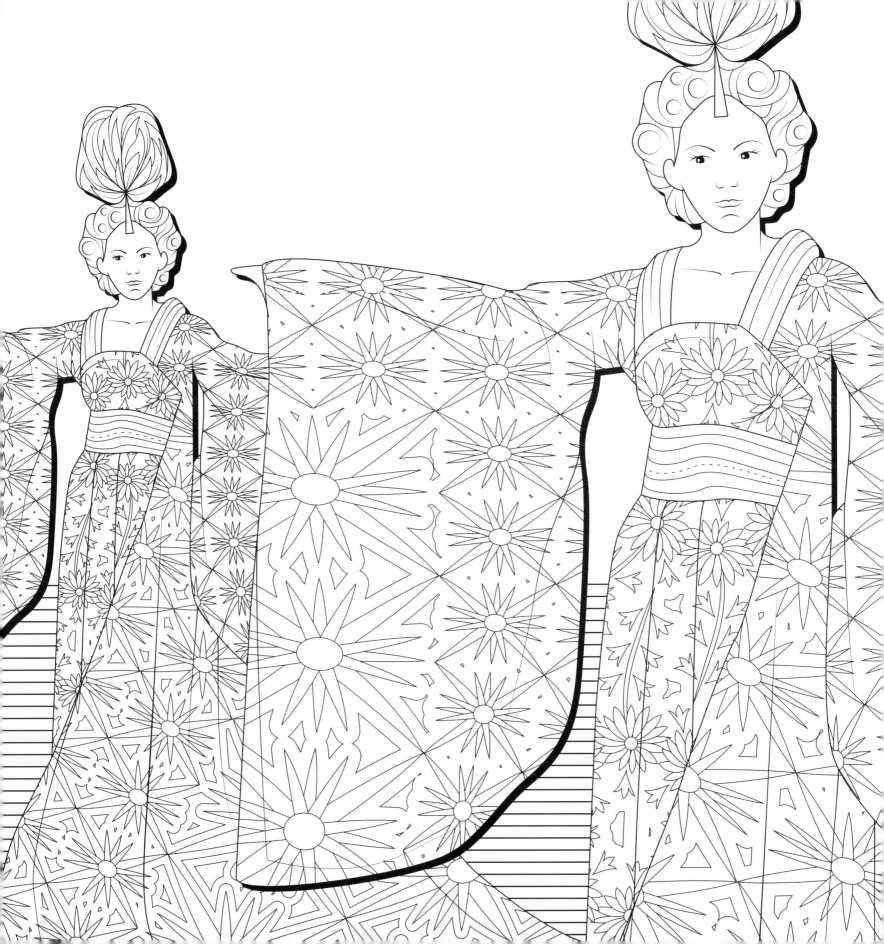

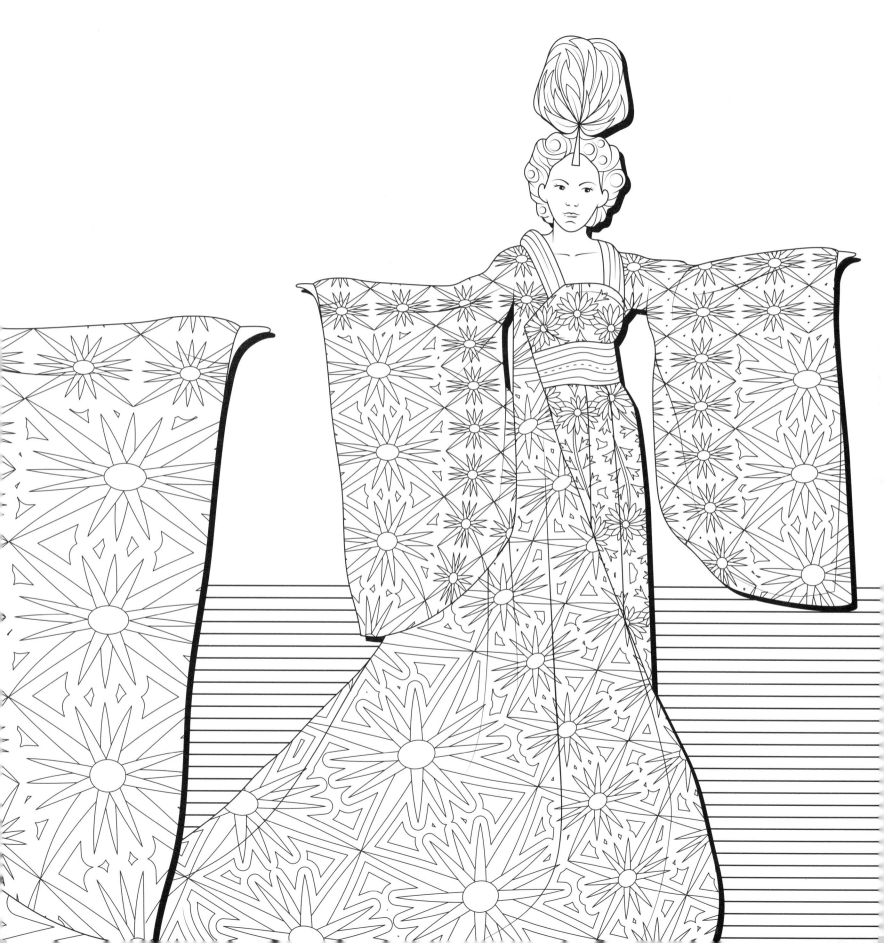

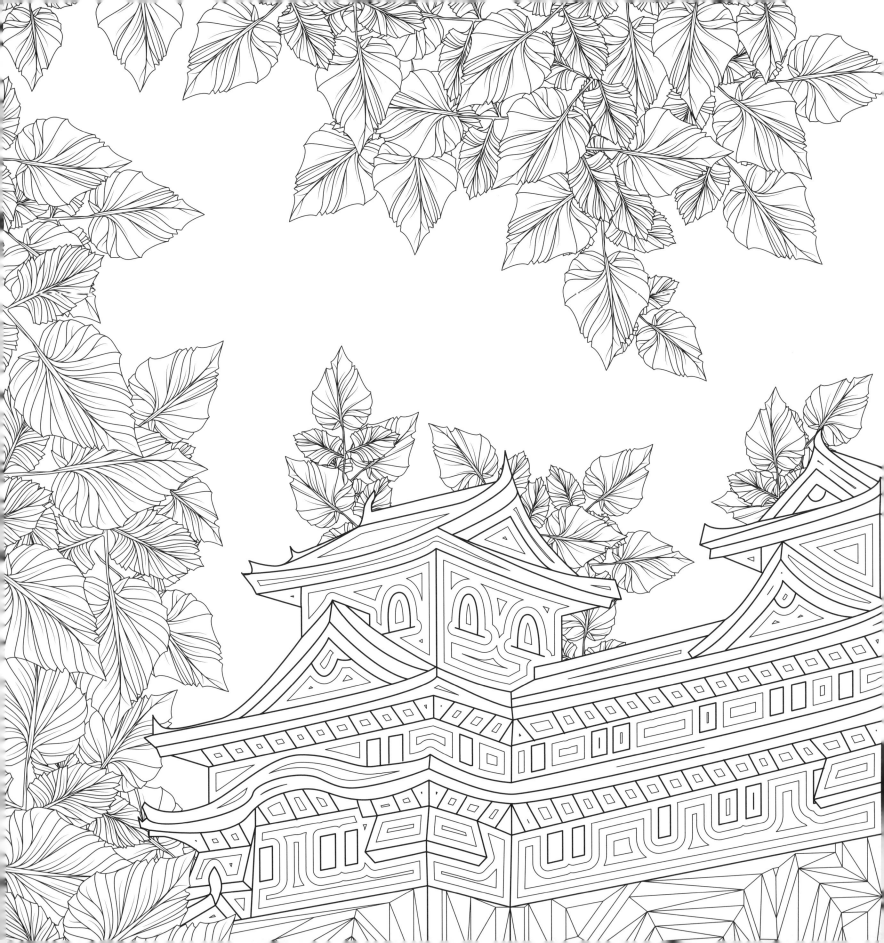

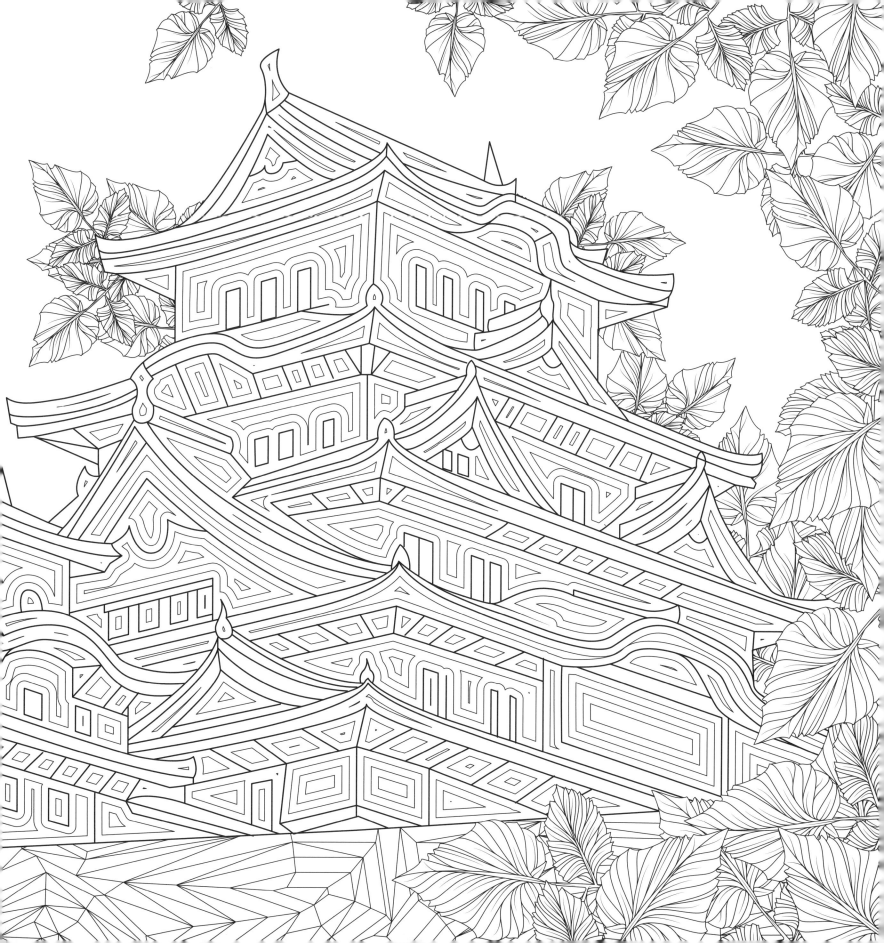

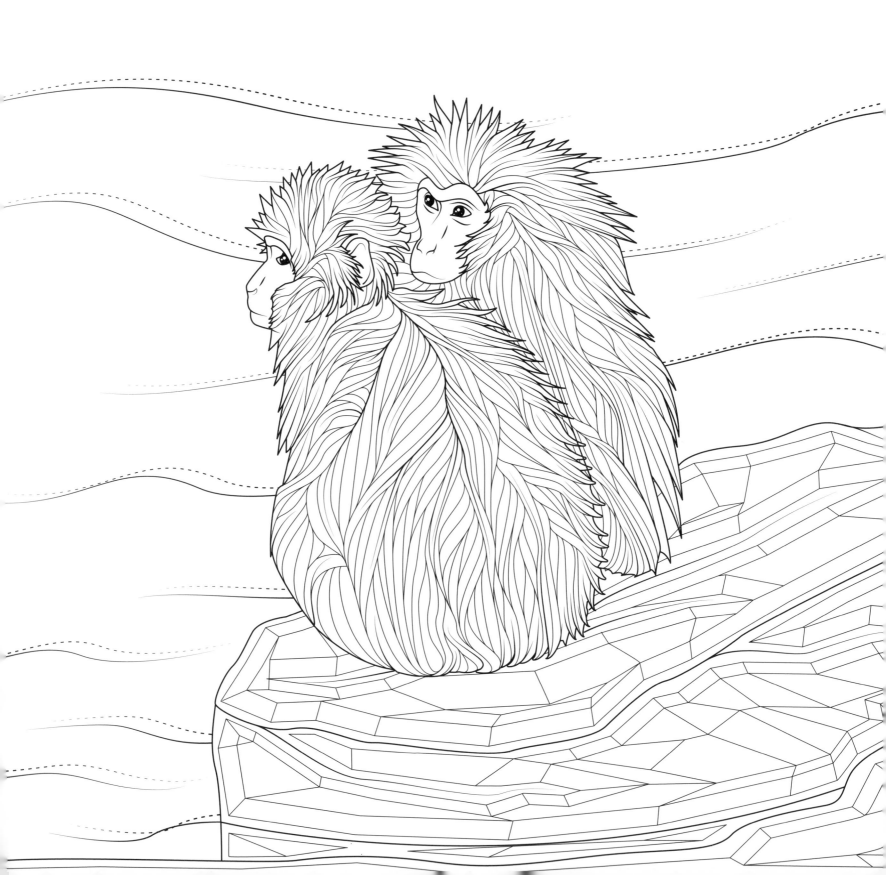

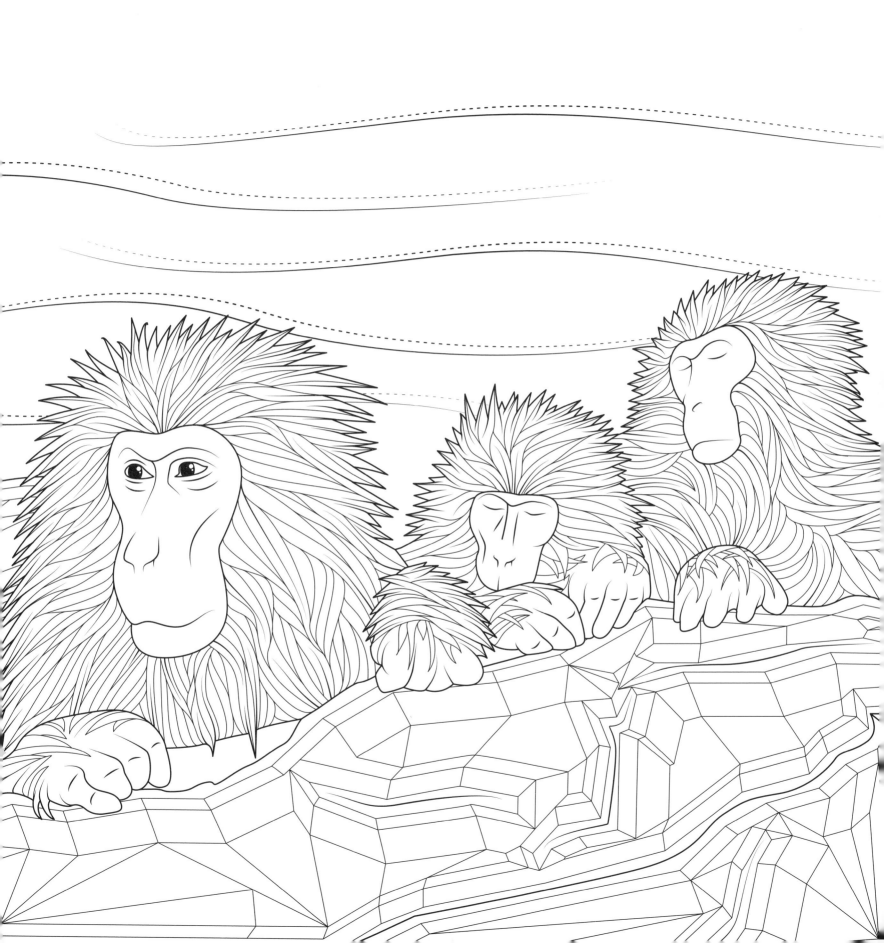

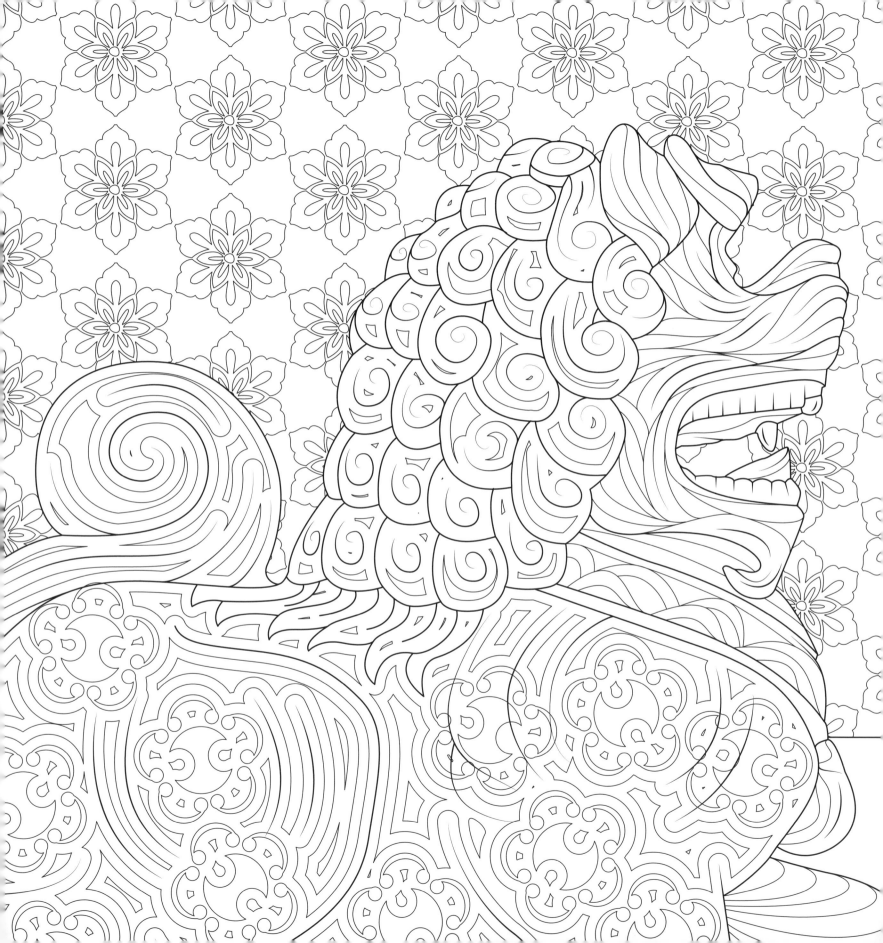

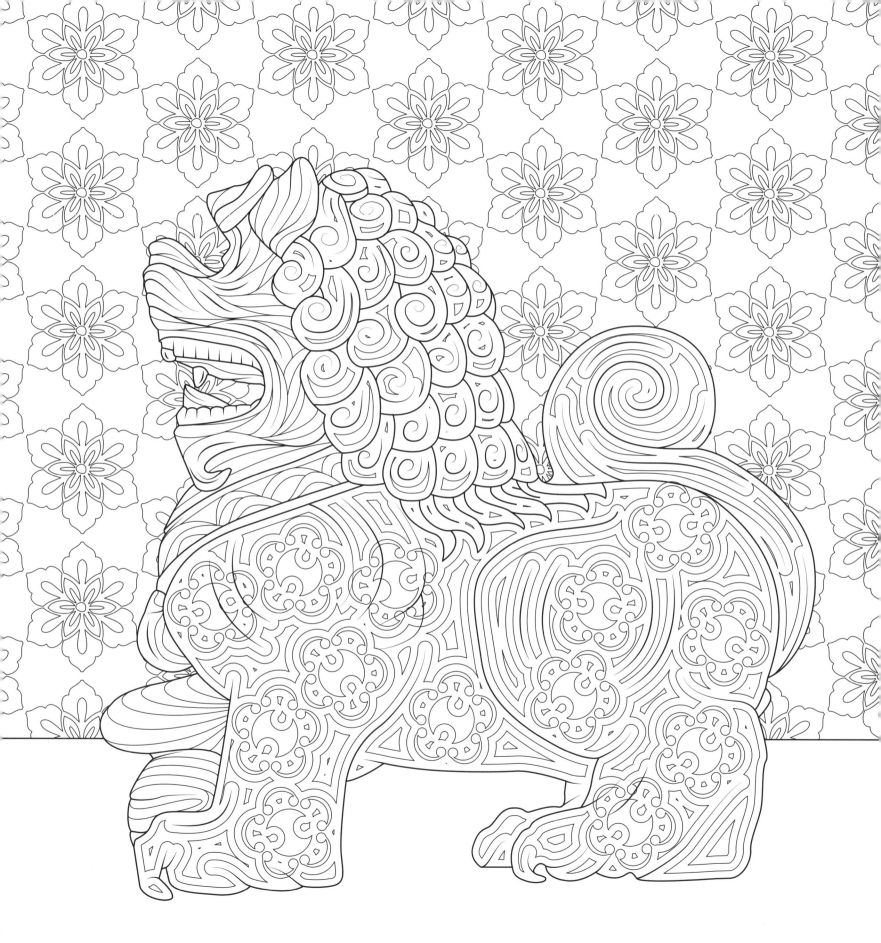

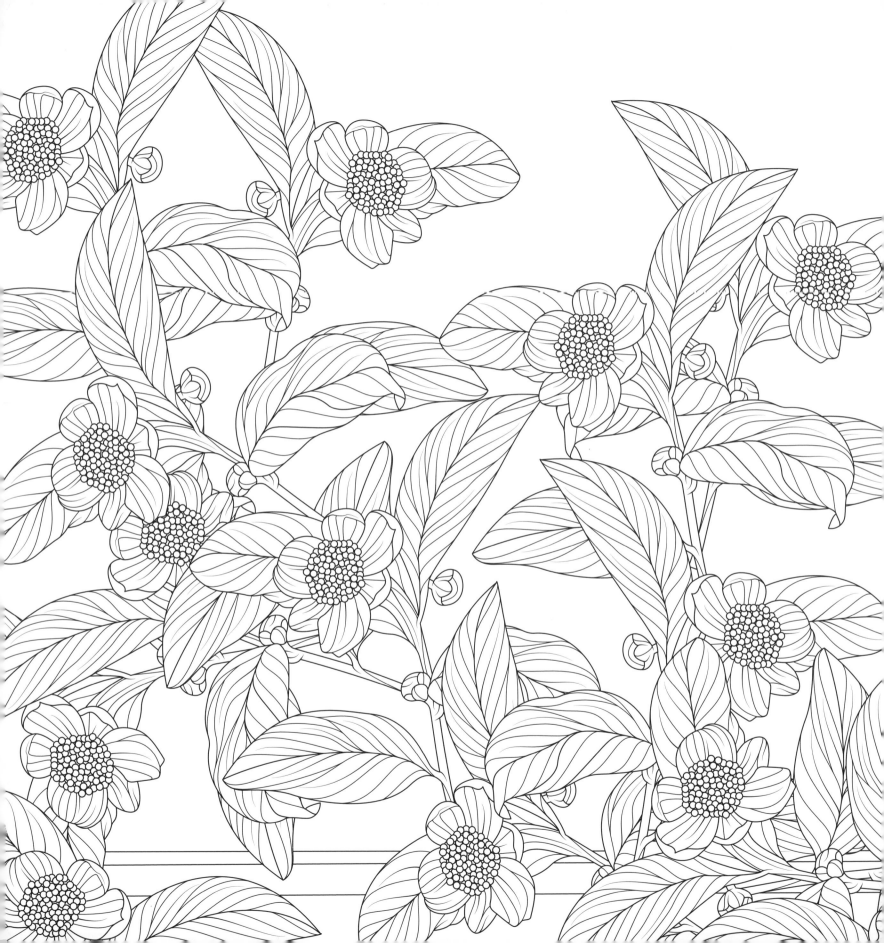

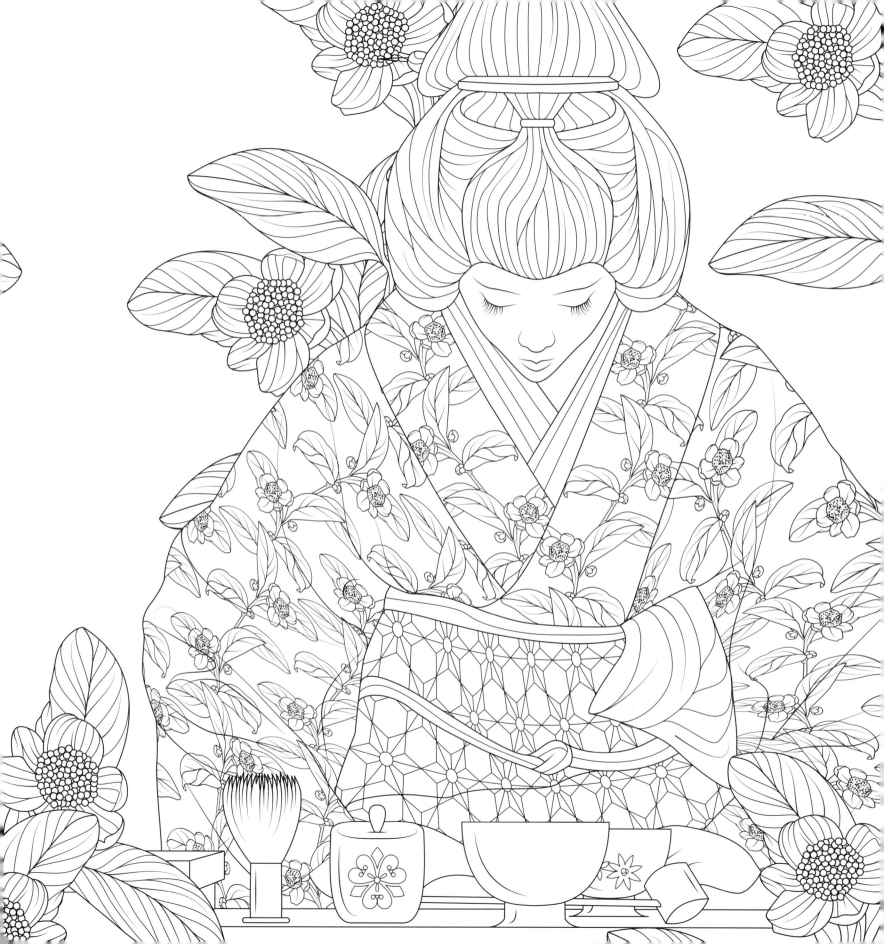

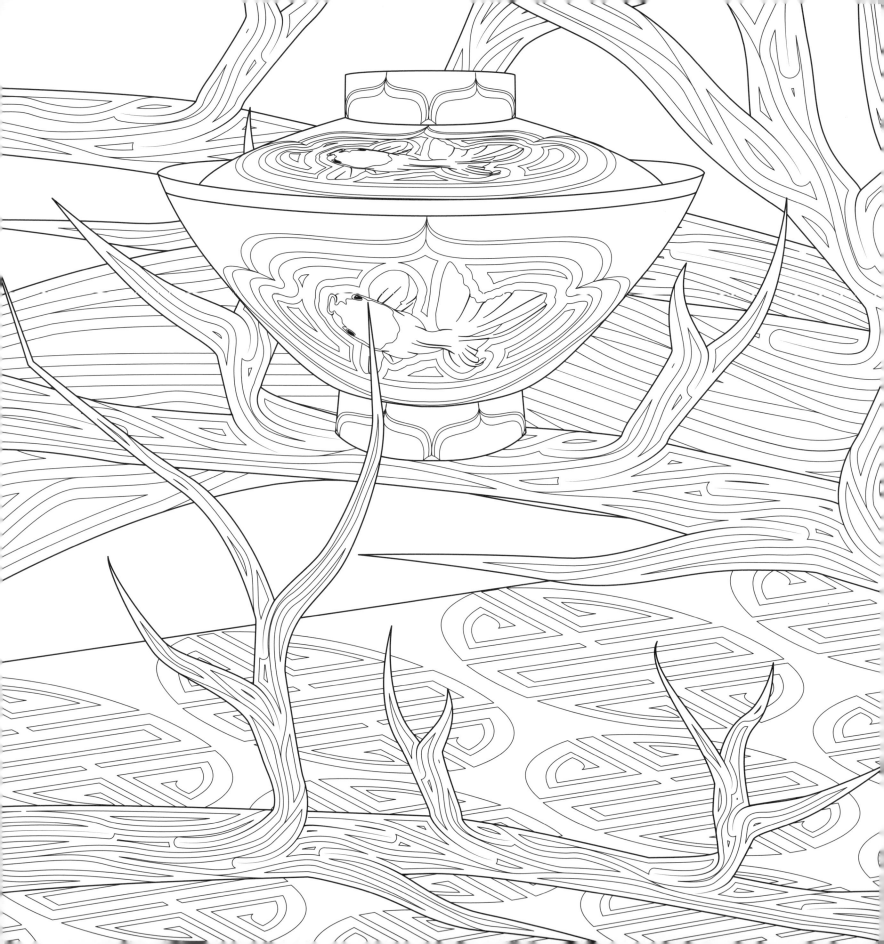

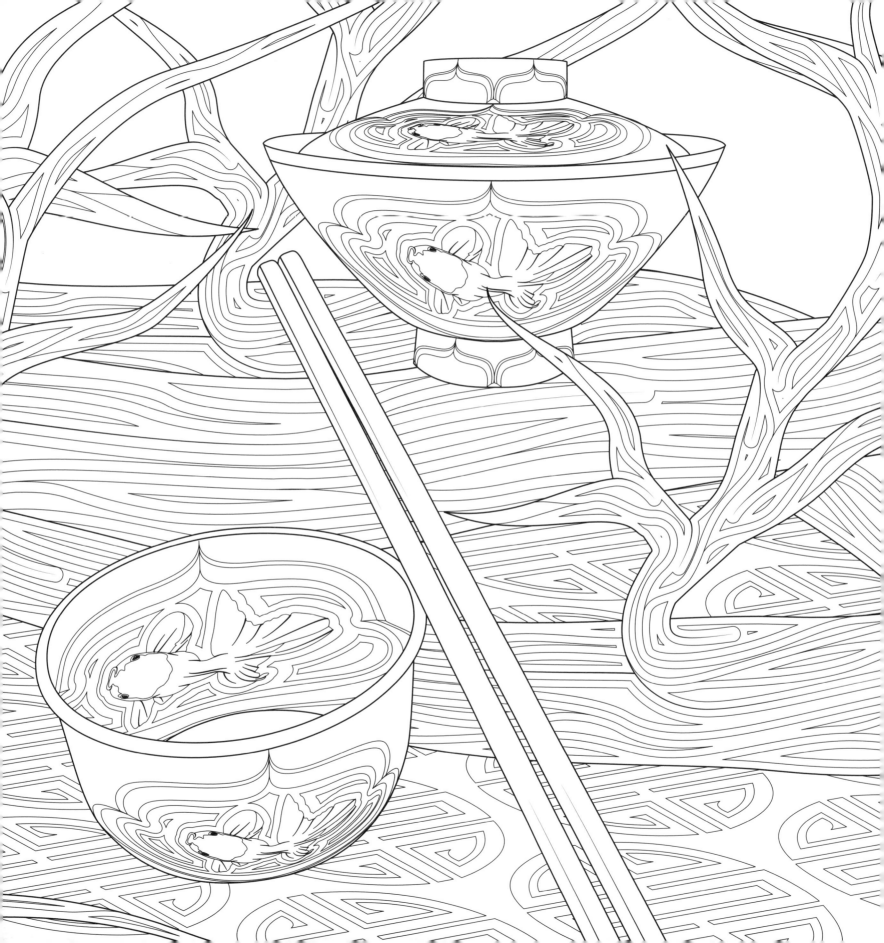

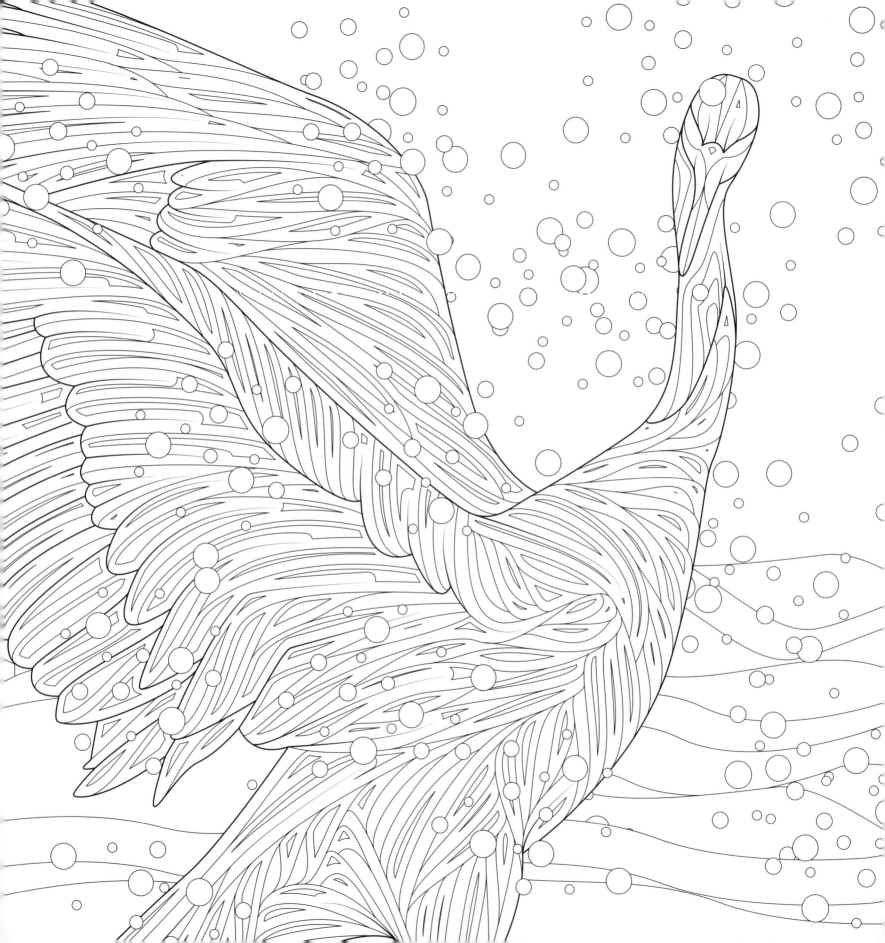

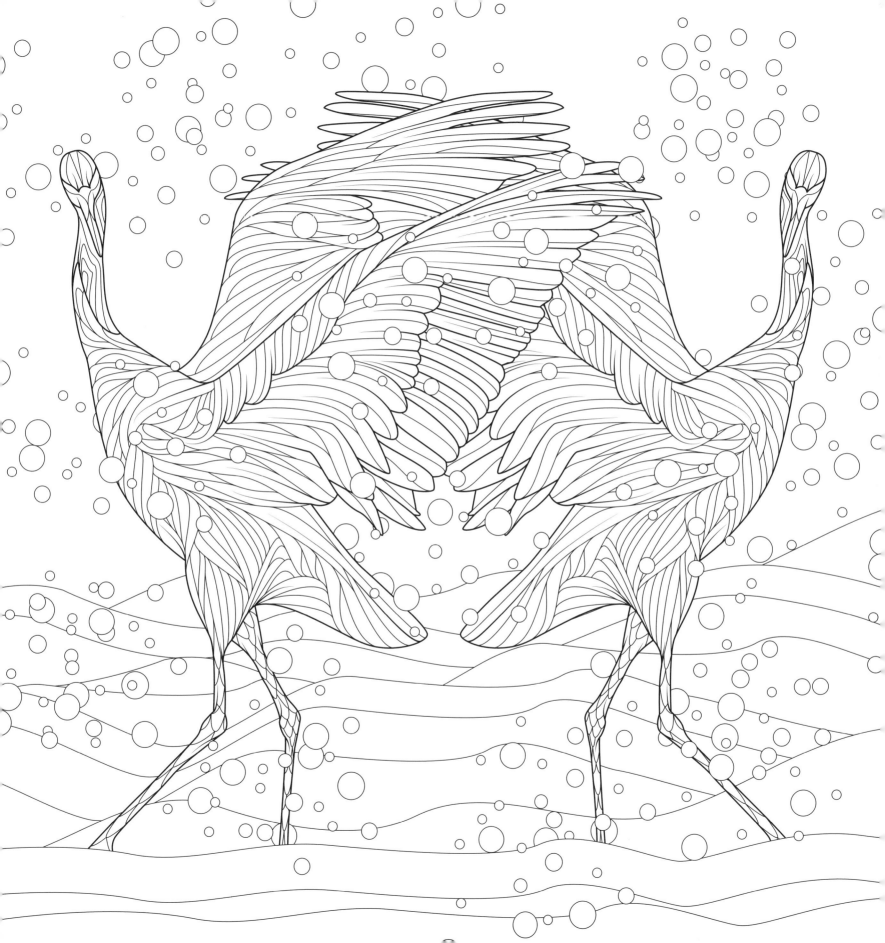

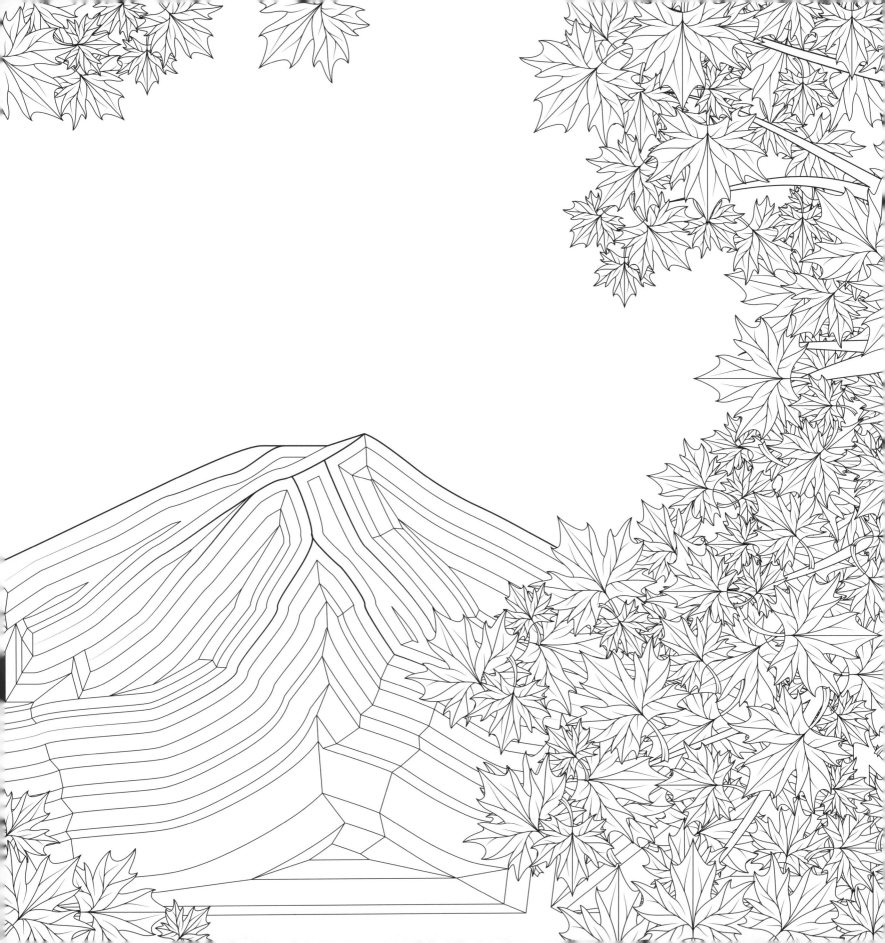

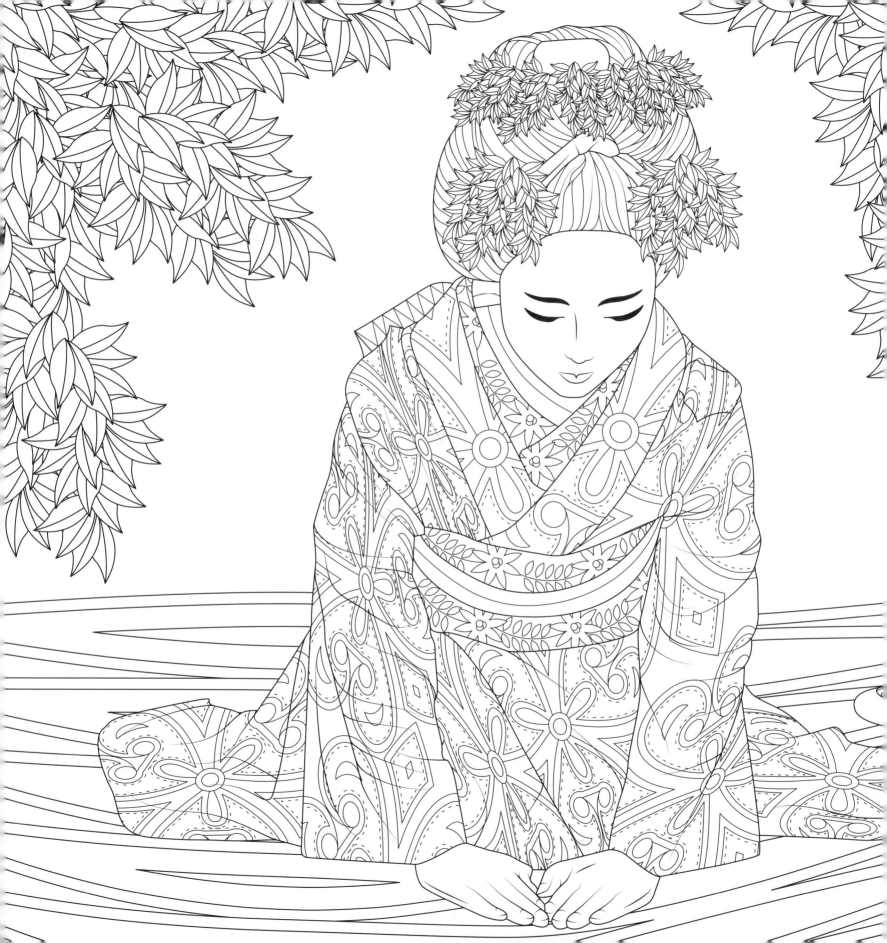

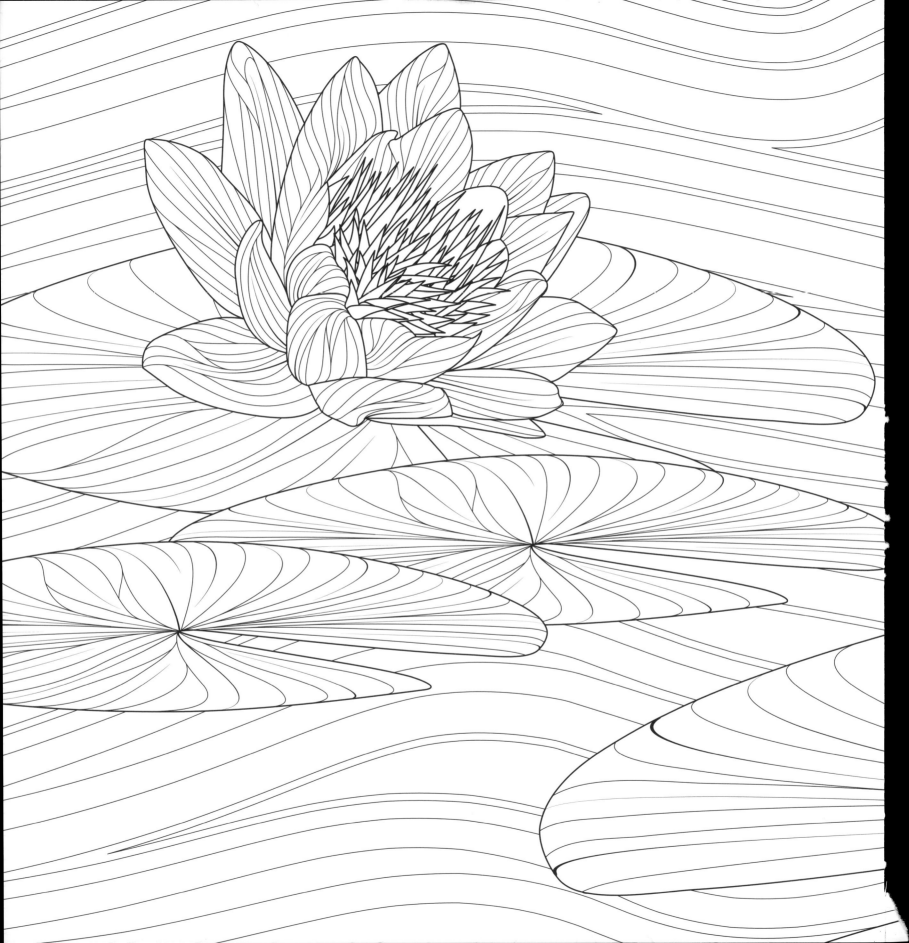

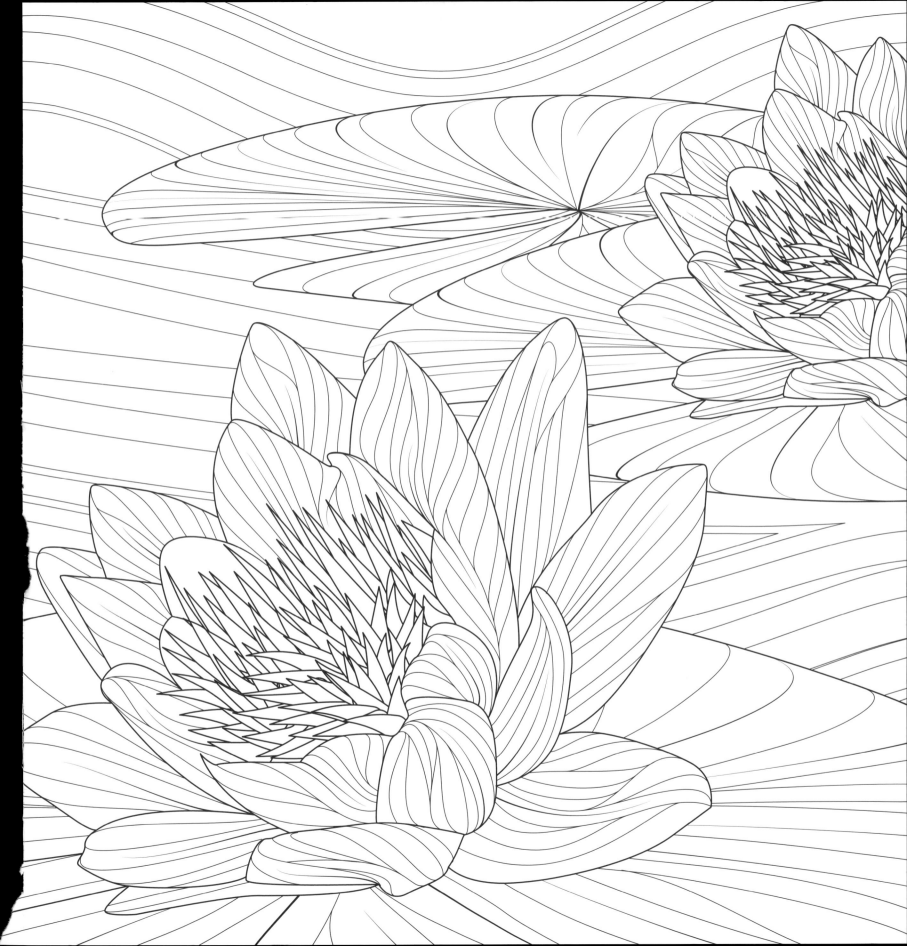

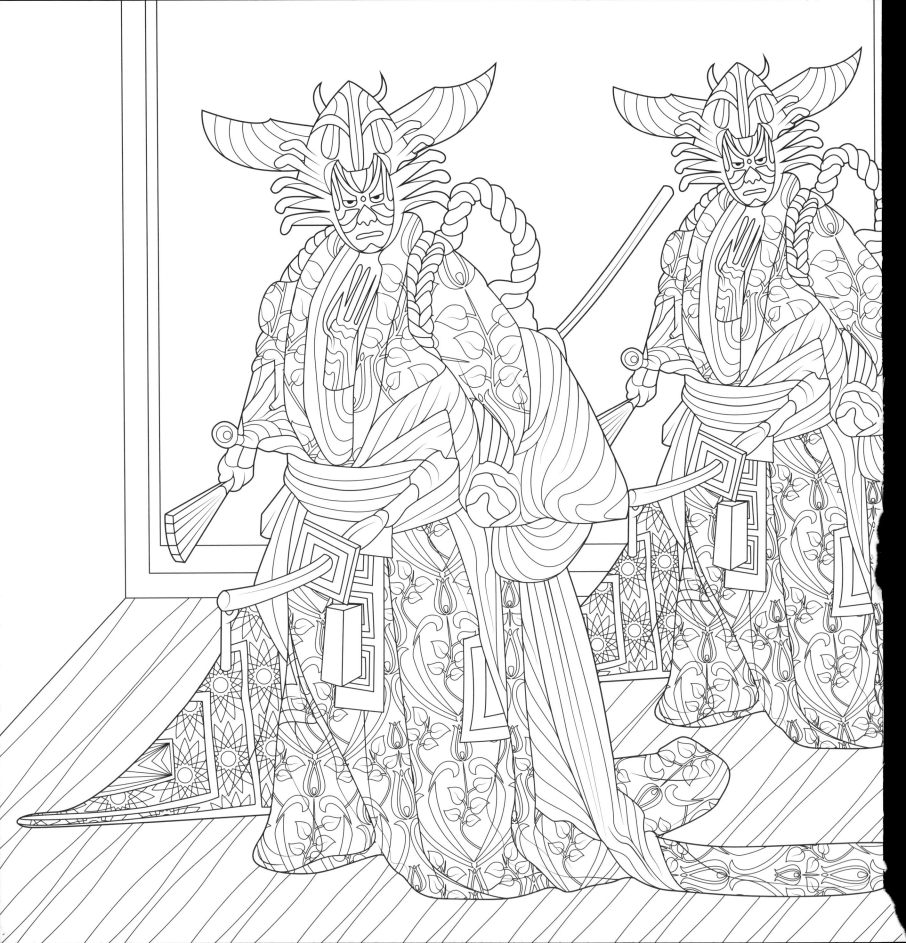

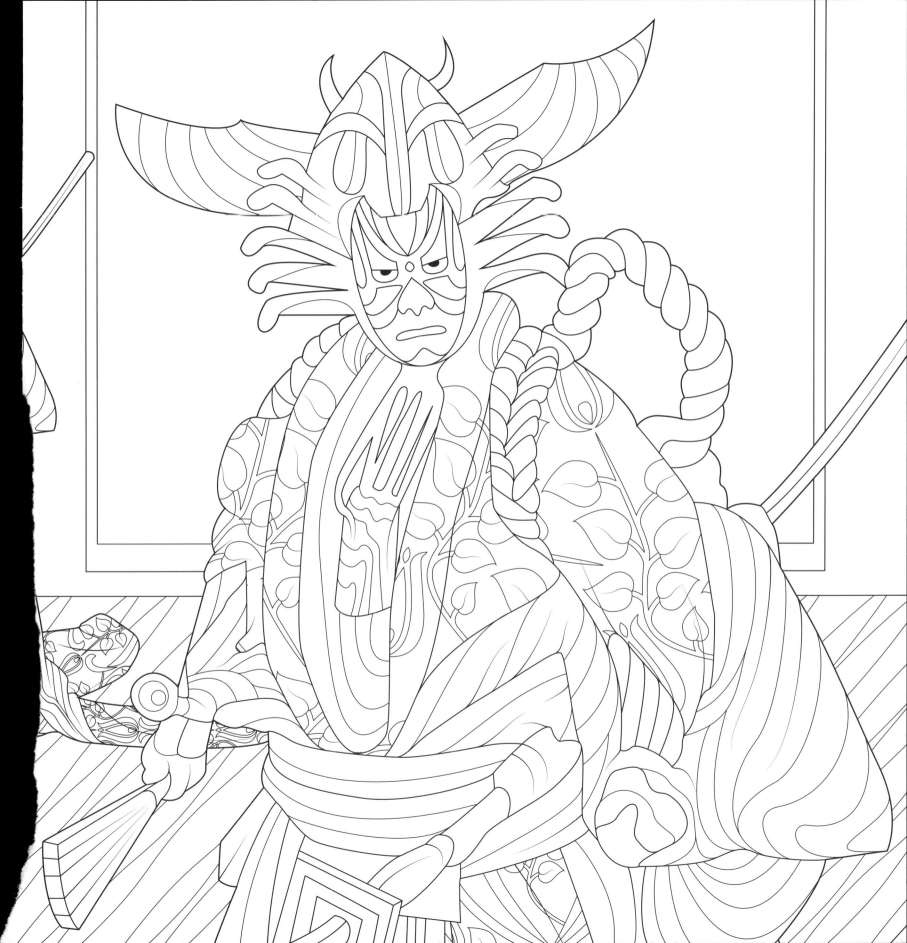

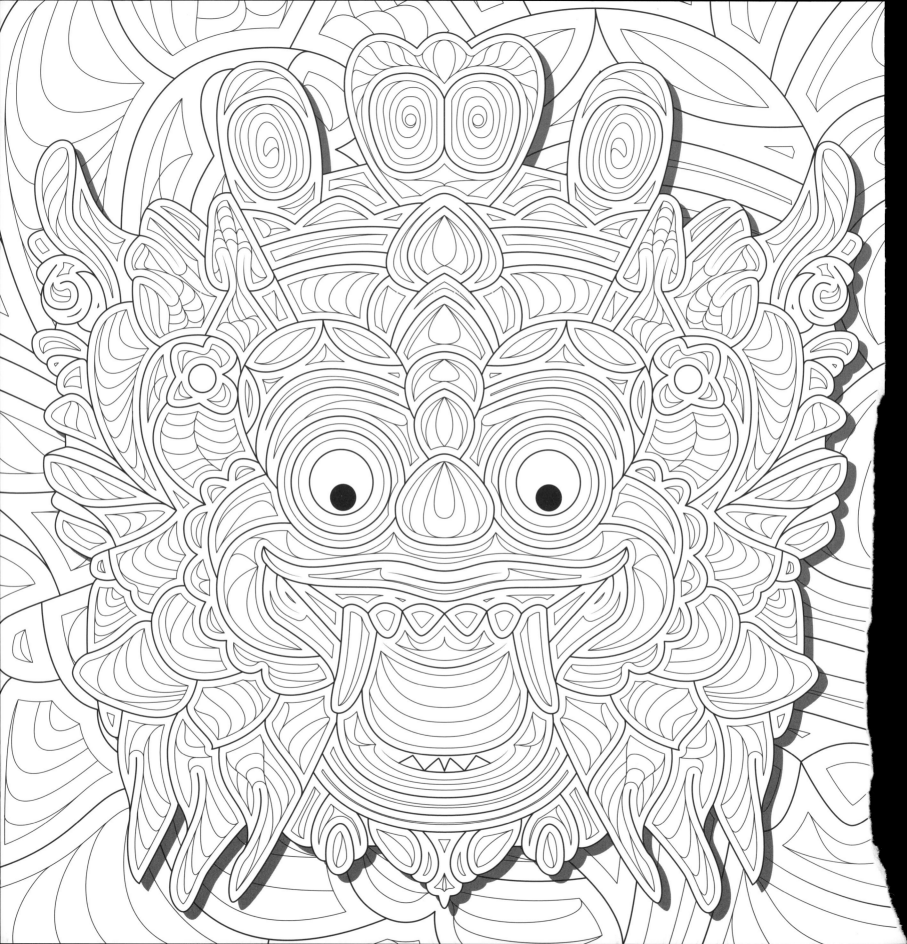